Venice through Canaletto's Eyes

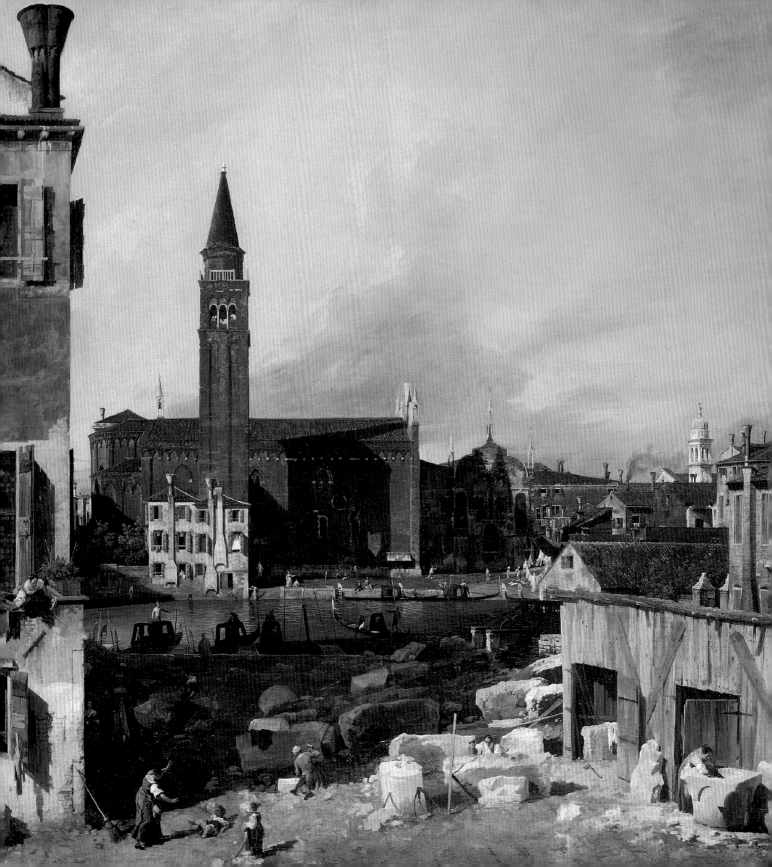

Venice through Canaletto's Eyes

David Bomford and Gabriele Finaldi

National Gallery Publications, London
Distributed by Yale University Press

In affectionate memory,
J.G. (Joe) Links
1904 – 1997

Acknowledgements

We would like to express our thanks for the assistance we have received from Martin Clayton and Jane Roberts of the Royal Library, Windsor Castle; Christopher Lloyd and Viola Pemberton-Pigott of the Royal Collection; Peter Barber at the British Library, London; Colin Harrison at the Ashmolean Museum, Oxford; Annalisa Perissa at the Gallerie dell'Accademia, Venice; Signora Luciana Moretti degli Adimari, Venice.

This book was published to accompany an exhibition at:
The National Gallery, London
15 July – 11 October 1998
York City Art Gallery
24 October 1998 – 3 January 1999
Glynn Vivian Art Gallery, Swansea
16 January – 14 March 1999

Supported by The Bernard Sunley Charitable Foundation

First published in Great Britain in 1998 by
National Gallery Publications Limited
5/6 Pall Mall East, London SW1Y 5BA

ISBN 1 85709 219 8 paperback
525280

British Cataloguing-in-Publication Data.
A catalogue record is available from the British Library.
Library of Congress catalog card no. 98-066511

Editors Diana Davies and Jan Green
Designer Isambard Thomas
Printed and bound in Italy by Grafiche Milani

Cover illustrations
Front *Venice: The Upper Reaches of the Grand Canal with S. Simeone Piccolo*, detail
Back *A Regatta on the Grand Canal*, detail

Frontispiece *'The Stonemason's Yard'*, detail

All illustrations are of works by Canaletto unless otherwise stated.

Contents

Foreword 6

Canaletto and Venice 7

Canaletto records Venice 12

S. Simeone Piccolo 20

Regatta Scenes 28

Venice: The Feast Day of Saint Roch 36

'The Stonemason's Yard' 42

Piazza San Marco 48

Technique and Style in Canaletto's Paintings 54

Bibliography 62

Notes 63

Works in the Exhibition 64

Foreword

Throughout his long career Canaletto painted his native city of Venice, its bridges and canals, the churches and the *campi*, and the spectacular complex of buildings around St Mark's Square. We still thrill at how Canaletto captured the Venetian sunlight dancing on the roof tiles of the *palazzi* or bouncing off the surface of the water, the texture of the crumbling stucco on the façades, and at his reportage of the daily life of the Venetian boatmen, matrons, priests and beaux. Contemporaries admired his views for their accuracy, the Irish entrepreneur Owen McSwiney, who was one of the artist's earliest agents in Venice, commenting in a letter to the Duke of Richmond that, 'His excellence lyes in painting things as they fall, immediately, under his eye'. But Canaletto's views are not simply a dispassionate record of buildings and unchanging perspectives. His presumed objectivity was subject to highly refined artistic licence. He made subtle adaptations of the topography of the scene he was depicting; he combined viewpoints within a single picture or adopted impossible viewpoints; he removed buildings or added them, according to his requirements. This exhibition examines how Canaletto went about producing those views of the city that we have come to consider archetypal and canonic.

The exhibition, which opens in London and then tours to York and Swansea, is supported by the Bernard Sunley Charitable Foundation, long-standing friends of the National Gallery. Once again, we would like to express our thanks to them and to all those who have generously lent their works.

Neil MacGregor
Director

Canaletto and Venice

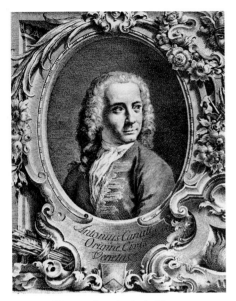

1 Antonio Visentini after a drawing by Piazzetta, *Portrait of Canaletto*. Engraving, detail. Frontispiece from the *Prospectus Magni Canalis Venetiarum*, Venice, 1735.

THE ONLY CERTAIN likeness of Canaletto appears on the frontispiece of a book of engravings after his views of Venice published in 1735 (fig. 1). Underneath the portrait is an inscription which affirms the ancient Venetian citizenship of his family: *Antonius Canale. Origine Civis Venetus*. While he was not a patrician and could play no part in the government of the state, his social status gave him certain privileges, such as the right to bear arms. He was very proud of his Venetian origins and, even today, the names of Canaletto and Venice, the city of his birth, are inextricably linked.

The large map of Venice produced by Ludovico Ughi in 1729, when Canaletto was in his early thirties and about to embark on the most prolific phase of his career, shows the two large island masses which form the city separated by the snaking Grand Canal, with the smaller islands of the Giudecca to the south (fig. 2). In the upper right-hand corner is a personification of Venice wearing the Doge's *corno*, or ceremonial hat, holding a sceptre and trident, and riding in triumph over the waves. In the sixteenth century Venice had indeed, as the image suggests, been a great maritime power, its empire extending from the *terraferma*, a substantial portion of northern Italy, along the Adriatic coastline opposite the Italian peninsula and embracing Crete, Corfu and Cyprus. Centuries of mercantile trade had brought the city enormous prosperity and the stability of its elected oligarchic government had fostered the development of sophisticated social and institutional structures, as well as the patronage of fine ecclesiastical and secular buildings, many of them decorated with vast canvases by Titian, Veronese and Tintoretto.

By the beginning of the eighteenth century, however, the Venetian state was in decline. With most of its empire lost, the city became the stage for a burgeoning tourist industry. Large numbers of wealthy foreign visitors flocked to the Venetian lagoon to admire the incomparable views and participate in the seemingly endless succession of carnivals, regattas, festivals and public ceremonies, and to patronise the seven theatres, two hundred cafés and restaurants, and the numerous casinos and brothels that the city had to offer. It was the Grand Tourists from northern Europe, rather than the Venetians, who acquired Canaletto's view paintings to remind them of the majestic and ethereal beauty of the city.

Giovanni Antonio Canal, better known as Canaletto, was born near the Rialto Bridge in October 1697. He was trained by his father, Bernardo, a painter of theatrical scenery. They were working together in Rome from before 1720, the year in which their names appear on a printed libretto for having designed the scenery for a Scarlatti opera. Canaletto began to establish his reputation as a painter of Venetian *vedute* (views) in the early 1720s. He sold some of these works at open-air exhibitions, like the one shown in the painting of *Venice: The Feast Day of Saint Roch* (fig. 35), but he soon began receiving

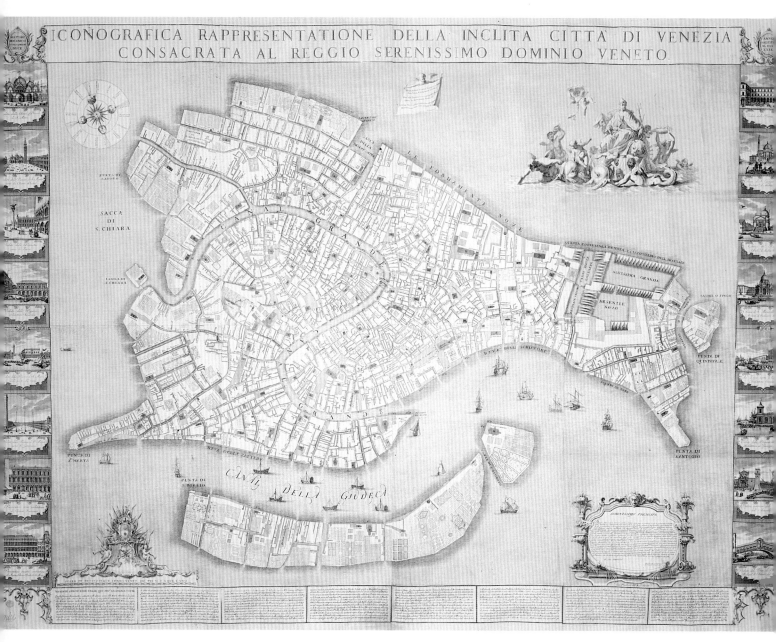

2 Ludovico Ughi, *Map of Venice*, 1729. 152 x 215 cm.
London, The British Library.
One of the finest eighteenth-century maps of Venice, it
shows the city as it was when Canaletto embarked upon
the most prolific phase in his career as a view painter in
the 1730s.

8

Map point A *Venice: The Upper Reaches of the Grand Canal with S. Simeone Piccolo*, 1738. The view is at the top of the Grand Canal, looking south-west. The church on the left is S. Simeone Piccolo and the façade of the church of the Scalzi is on the right.

Map point B *Venice: A Regatta on the Grand Canal*, about 1735. The view is from Palazzo Foscari at the Volta del Canal to the Rialto Bridge.

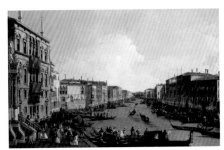

Map point B *A Regatta on the Grand Canal*, about 1740. Essentially the same view as the previous picture but from a slightly higher viewpoint.

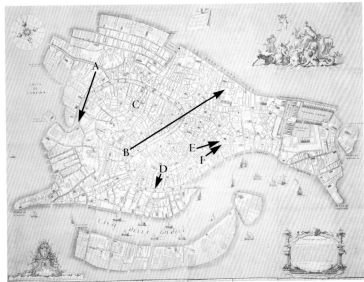

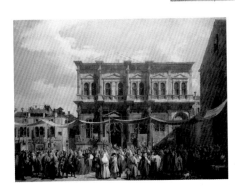

Map point C *Venice: The Feast Day of Saint Roch.* We are looking across the narrow Campo San Rocco at the façade of the Scuola. The unadorned façade of the church of S. Rocco is on the right.

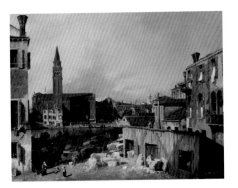

Map point D *Venice: Campo S. Vidal and Santa Maria della Carità ('The Stonemason's Yard')*, 1727–8. The view is across the Grand Canal from the Campo San Vidal. The church of the Carità is seen from the side.

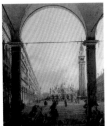

Map point E *Venice: Piazza San Marco*, late 1750s. From one of the arches on the west end of the piazza looking towards the basilica of S. Marco.

Map point F *Venice: Piazza San Marco and the Colonnade of the Procuratie Nuove*, late 1750s. The view is from the south side of the piazza.

significant commissions, such as the one from the wealthy Lucchese merchant Stefano Conti in 1725 (see figs. 9 and 11).

In 1726 he came into contact with Owen McSwiney, an Irish entrepreneur who had fled from creditors in London and settled in Italy. Canaletto was persuaded by him to participate, along with several other artists, in a project for a series of allegorical tomb paintings for the second Duke of Richmond. In addition Canaletto painted some small views of Venice on copper for the Duke and thus began a veritable love affair between British collectors and the artist. The affair was nurtured over a period of nearly thirty years by an English merchant called Joseph Smith (c.1675–1770) who had settled in Venice in the early years of the eighteenth century and in 1744 was appointed British Consul. Smith acted both as patron and agent to the artist, securing for him major commissions like the series of twenty-four pictures ordered by the fourth Duke of Bedford in the mid-1730s (all of which are still at Woburn Abbey in Bedfordshire) and the twenty-one pictures made for George Grenville at about the same time and now dispersed (the so-called Harvey series). A steady stream of Grand Tourists from the British Isles ensured that Canaletto was very busy throughout the 1730s and from this period onwards some measure of studio participation in many of his works is apparent.

Smith himself owned a large group of paintings and drawings by Canaletto which in 1762 he sold to King George III. Today, the Royal Collection has the largest and finest collection anywhere of works by him, comprising fifty autograph paintings and 143 drawings. In 1735 Smith promoted the publication of a book of fourteen engravings of views of the Grand Canal, the *Prospectus Magni Canalis Venetiarum*, executed by Antonio Visentini after the paintings by Canaletto in his collection. This served as a vehicle for publicising the artist's work and proved so successful that in 1742 a new edition appeared

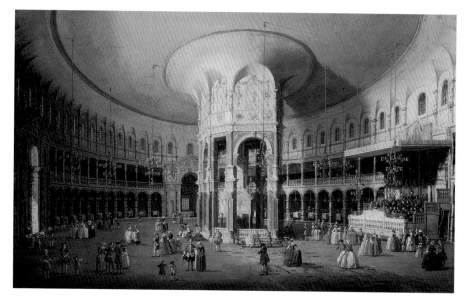

3 *London: Interior of the Rotunda at Ranelagh*, 1754.
Oil on canvas, 47 x 75.6 cm.
London, The National Gallery.
Painted for Thomas Hollis, the painting shows the Rotunda at Ranelagh Gardens in Chelsea, a public venue for various forms of entertainment. It was built in 1741 and closed in 1803, and was later demolished.

4 *Capriccio: A Colonnade opening on to the Courtyard of a Palace,*
signed and dated 1765.
Oil on canvas, 131 x 93 cm. Venice, Accademia.

with twenty-four more engraved views. In the early 1740s Canaletto also made a group of etchings, mostly of *capricci* (imaginary or capricious scenes) based on Venetian or Veneto views.

With the outbreak of the War of Austrian Succession in 1740 the flow of tourists to Venice was dramatically reduced and Canaletto decided that if his patrons could not come to him, he would go to them. In 1746, therefore, he settled in London where he stayed for a period of about ten years, making one lengthy visit to Venice in 1751 and possibly another in 1753. The engraver and antiquary George Vertue recorded his arrival in his notebook:

Latter end of May [1746] came to London from Venice the Famous Painter of Views Canalletti of Venice the multitude of his works done abroad for noblemen and Gentlemen has procured a great reputation & his great merit and excellence in that way, he is much esteemed and no doubt but that his Views and works he doth here will give the same satisfaction – tho' many persons already have so many of his paintings.

Despite the rumour that circulated briefly in London in 1749 that he was not the real Canaletto from Venice but an impostor, the artist received important commissions from, among others, the Duke of Richmond, who had already had some of his early views of Venice, Sir Hugh Smithson, later the first Duke of Northumberland, who commissioned views of the newly constructed Westminster Bridge, and Lord Brooke, who invited the artist to Warwick Castle where he painted several delightful works. Some of his most interesting and unusual English paintings were made in 1754 for the wealthy writer and collector Sir Thomas Hollis, who had met Consul Smith in Venice (fig. 3). Canaletto's influence on view painting in England was considerable, particularly on watercolour painters.

In 1755 or 1756 Canaletto returned definitively to Venice. By this time his nephew and most brilliant pupil, Bernardo Bellotto (1721–80), had been working at Dresden as court painter to the Elector Augustus II of Saxony for more than eight years with great success and was soon to move on to Vienna, Munich and Warsaw. Francesco Guardi (1712–93), also a native of Venice, was beginning to establish himself as a successful *vedutista* in these years – although, contrary to popular legend, he seems never to have been Canaletto's pupil. His style is very distinctive and quite different from Canaletto's, although there are some intriguing similarities with the latter's works of the 1720s.

Canaletto's later works, including some produced in his English period, became somewhat formulaic in execution, nevertheless the late Venetian views are often highly original in conception and design and he made bold use of dramatic perspectives. He was elected to the Venetian Academy only in 1763, a delay that was almost certainly due to the low status accorded to view painters. His reception piece, which is signed and dated 1765, was a large architectural *capriccio* in which he demonstrated his perspectival skill and his artistic ingenuity (fig. 4), qualities that the Academicians had no difficulty in admiring. He died in April 1768.

Canaletto records Venice

CANALETTO DREW AND painted his native city incessantly. Even in the last decade of his life, he was observed 'making a sketch of the Campanile in St Mark's Place' (see p.48), apparently still recording the Venetian scene when it would seem that there was not a single stone of the city that he had not drawn innumerable times before.

Canaletto has often been thought of as the dispassionate recorder of the Venetian cityscape – an unprejudiced retina attached to a dextrous hand that absorbed and then reproduced the appearance of the palaces, canals, *campi* (Venetian squares) and churches of the city, and of the clear brilliant light that falls upon them and is reflected on the glassy surface of the water. His views are considered to be accurate portraits, quasi-documents, even photographs *avant la lettre*. In 1727 Owen McSwiney wrote to the Duke of Richmond that 'His excellence lyes in painting things as they fall, immediately, under his eye', and the engraver and writer Antonio Maria Zanetti, writing shortly after the artist's death, referred to the *aggiustatezza* and *la vera* of his views, their 'accuracy' and 'reality'. They have acquired canonical status and to an extent, even today, we view Venice through the eyes of Canaletto.

In reality, of course, Canaletto's views are artful constructions, based on a thorough knowledge of the appearance and character of the city but filtered and interpreted, the elements revised and rearranged, added to or removed.[1] Canaletto often fuses multiple, and sometimes invented, viewpoints; some of the views are from angles blocked by buildings that his imagination would simply remove, opening up the scene like a stage set. He alters the proportions and shapes of individual buildings and sometimes includes buildings that are not there. A comparison of the same building in different paintings and drawings shows very considerable variations between them: for example, the building which housed the Zecca, the mint near the Marciana Library, is shown with eight, or seven or five bays, and sometimes with nine (which is correct).[2] He frequently remodels the curves of the Grand Canal; his shadows are at times inconsistent and on occasion the sun is in quite the wrong part of the sky. The rhetoric of persuasion in Canaletto's views, however, is overwhelming and the spectator has the impression that the view is painted as seen. It is partly in this that their brilliance and their attraction lie.

The Venetian *veduta* was not invented by Canaletto. It was practised most notably by Luca Carlevaris (1663–1730), a painter from Udine, more than a generation earlier. Carlevaris's paintings, which usually show the area around S. Marco, often have the character of a visual chronicle and clearly betray their descent from the large ceremonial views of Gentile Bellini and Carpaccio. Carlevaris recognised that a market for the Venetian view was beginning to develop and in 1703/4 he produced a series of 104 etchings entitled *Fabriche, e Vedute di Venetia* (The Buildings and Views of Venice) which, in its overt effort to document the appearance of many parts of the city, marks something

5 *Buildings along the Grand Canal looking towards the Volta del Canal*, about 1730. Pencil and ink on paper, each leaf 228 x 170 mm. Annotations include: *balconi* (windows), *con schuri* (with shutters), *P,P* (pilasters), *Sporco* (dirty) and *chiaro* (light). Accademia Sketchbook, fols.17v, 18. Venice, Accademia.

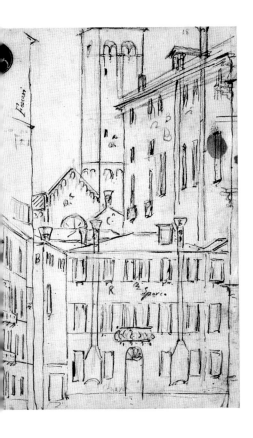

of a new departure. Canaletto sometimes based his own painted views directly on those of Carlevaris but he mostly worked from his own drawings of Venice.

Some 500 drawings by Canaletto have survived – although he undoubtedly made many more – and it is important to distinguish between their different functions.[3] They range from highly finished works – produced for collectors (most notably Consul Smith) who admired Canaletto's brilliance as a draughtsman as much as, if not more than, his expertise as a painter – to annotated jottings and diagrams in sketchbooks made in his wanderings about the city.

The raw material for Canaletto's depictions of Venice is to be found in his sketches (or *scaraboti* – summary sketches – as Canaletto himself described them) and, in particular, the one surviving complete sketchbook now in the Accademia in Venice.[4] The sketchbook is bound in vellum and consists of seventy-four numbered leaves and a few blank pages. The book, which measures 22.8 x 17 cm, is small enough to fit in a capacious pocket. The drawings in it are almost all either in lead pencil or in ink, or ink over pencil; it has been suggested that these latter sketches may have been started on the spot in pencil and finished off later in the studio with ink. In just a few of the sketches, red chalk is used. Most of the drawings are in outline with no shading and are essentially diagrams of buildings and cityscapes. They are extensively annotated in Canaletto's own hand, to give the names of buildings and shops, to identify topographical features, to mark changes in scale between one building and the next and to indicate light, shade and different colours. The sketchbook appears to date from the late 1720s to the early 1730s.

In one double page (fig. 5), showing the unfinished Palazzo Rezzonico at the left (inscribed *Ca Bon*, its former name) and the side wall of Palazzo Balbi at the right, Palazzo Foscari (the vantage-point for the regatta scenes, see p.28) is included twice on the right-hand page. It is first drawn in scale with the buildings on the left page (and annotated *foscari*) and then its end wall is drawn again, much larger in scale (with the repeated but capitalised annotation *Foscari*); the sketch continues with the little house on the Rio Foscari (marked *Sporco*) and the side of Palazzo Balbi. Behind is the campanile of the Frari church, too tall for the page, and the top of it is drawn separately on the left page.

Many of the sketches were made in sequence. Canaletto would survey a wide sweep of the Grand Canal and record the whole panorama in drawings that spread over as many as twelve successive pages. There is a technical curiosity about these continuous sequences. Sometimes they start logically at the left and continue left to right through the successive double pages, the drawing at the right edge of each *recto* continuing around to the left edge of its corresponding *verso*. More frequently, however, Canaletto begins at the right-hand side of the panorama and then records the scene right to left in successive double-page openings. Recorded in this way, the drawing cannot be read continuously by turning the pages, since the left side of the first double page joins to the right side of the second double page, and so on. Canaletto was clearly right-handed and the left to right method would seem to be the natural one. Why he should so often have adopted the more awkward reverse direction remains to be satisfactorily explained.

There is no doubt that the drawings in the Accademia sketchbook were made on the spot, even if some of them were strengthened with ink later in the studio. There are also more elaborate drawings for entire compositions probably made out of doors – and the preparatory studies for Canaletto's most fully documented early commission are notable examples. Stefano Conti was a textile merchant in Lucca and a collector of paintings, including three Venetian views by Carlevaris.[5] In 1725 he contacted his long-standing agent in Venice, Alessandro Marchesini, apparently with a request for more works by Carlevaris. In a now famous letter of July 1725, Marchesini replied that there was a painter in Venice, 'Sig.r Ant. Canale', who produced the same type of painting as Carlevaris, but whose work astonished everybody because of his skill in painting the effects of sunlight. This moment seems to mark the eclipse of Carlevaris by his younger rival, a process said to have caused the older man much bitterness. Marchesini also wrote that Canaletto painted his pictures 'sopra il loco' – on the spot – a claim which is likely to be untrue and subsequently caused much confusion. On Conti's behalf Marchesini ordered two paintings from Canaletto, which, after some delay and a little haggling over prices, were completed in November 1725. The artist, who quickly acquired a reputation for charging high prices, had demanded thirty *zecchini* a picture but reluctantly reduced this to twenty. Two more pictures were commissioned, which were completed in May and June 1726.

The first two Conti paintings are both views of the Grand Canal from points just north of the Rialto Bridge, one looking back at the bridge and the other looking north up the Grand Canal (figs. 9 and 11). Canaletto's two preliminary drawings for these compositions still survive (figs. 10 and 12), as well as his correspondence with Conti in which he describes them and acknowledges payment. Comparison of the drawings, paintings and the actual topography of the scene (remarkably unchanged) reveals much about Canaletto's processes of recording Venice.

Both the painting, *Grand Canal: the Rialto Bridge from the North* (fig. 9), and its preparatory drawing (fig. 10) show Canaletto's habitual practice of combining more than one viewpoint in the same composition. The Palazzo dei Camerlenghi, adjoining the Rialto Bridge, is seen head-on from across the Canal, together with a view through to smaller buildings behind. However, if the Fabbriche Vecchie (to the right of it) were viewed from the same position, its end wall would be just visible (fig. 6). Conversely, from the viewpont from which the Fabbriche Vecchie must have been studied, the side wall of the Palazzo dei Camerlenghi becomes visible and the buildings behind can barely be seen (fig. 6). The two viewpoints seem to correspond to two small landing stages separated by one city block, still accessible today (fig. 8) – and one can easily imagine Canaletto sketching the left-hand two-thirds of the composition from one and then walking to the other to complete the right-hand part which, in the drawing, is noticeably less detailed. In this case, the adjustment was quite minor but there are many cases in which his departure from reality was extreme.

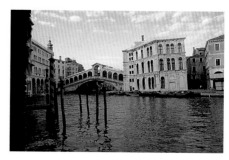

6 Modern photograph taken from map point **A** in fig. 8 (photo Sarah Quill 1998).

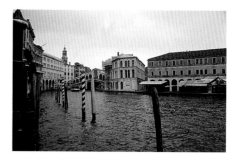

7 Modern photograph taken from map point **B** in fig. 8 (photo Sarah Quill 1998).

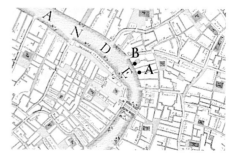

8 Detail of Ludovico Ughi's map, showing Canaletto's probable viewpoints (A & B) for figs. 9 and 10.

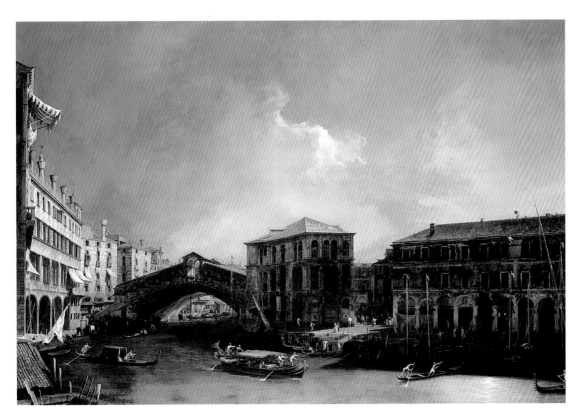

9 *Grand Canal: the Rialto Bridge from the North*, 1725.
Oil on canvas, 91.5 x 135.5 cm.
Private collection.

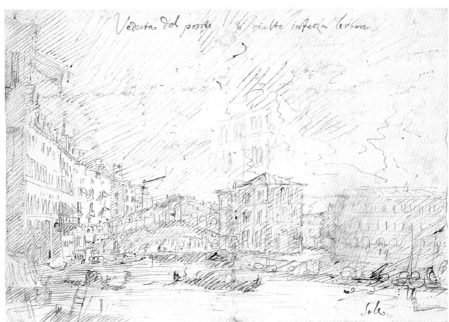

10 *Grand Canal: the Rialto Bridge from the North*, 1725.
Pen and brown ink with red and black chalk on paper,
140 x 202 mm.
Oxford, The Ashmolean Museum.

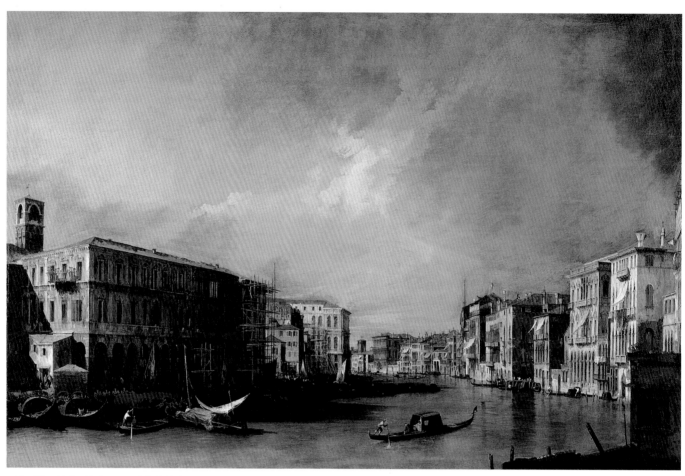

11 *Grand Canal: looking North from near the Rialto Bridge*, 1725.
Oil on canvas, 91.3 x 135 cm. Private collection.

It is fascinating to read Canaletto's own description of the picture, which focuses mainly on the narrative detail, in a document of November 1725:

the Rialto Bridge seen from the side of the Fondaco dei Tedeschi which is opposite the Palace of the Camerlenghi Magistrates and other Magistrates, with other buildings nearby which look on to the vegetable market where all kinds of vegetables and fruits are delivered to be distributed to the suppliers in the city. In the middle of the Canal is painted a Peotta Nobile with figures in it and four Gondoliers going at full speed and close to it a gondola having the livery of the Emperor's Ambassador.[6]

The Ashmolean drawing (fig. 10) is annotated with the word *Sole* in the water at the right – in exactly the same position as the reflection of the sun in the painting. The drawing for the other early Conti painting, *Grand Canal: looking North from near the Rialto Bridge* (fig. 12), is also inscribed with a single word in the water, *Fondamenta*, describing the vantage point beside the water from which the scene was viewed. Comparing this drawing and painting reveals another of Canaletto's practices in refining his images of the Venetian scene. The viewpoint of the drawing is more or less at normal eye level but, in the painting, the viewpoint has been raised to balcony level and the spectator now looks down slightly on the scene across the Grand Canal. This can be verified by comparing the horizontals on the end wall of the Fabbriche Nuove, the building at the left (adjacent to the Fabbriche Vecchie seen in the previous painting). This was a normal procedure for Canaletto and there are examples where he has begun with a sketch at ground level, raised his viewpoint for a more detailed drawing and then raised it again for a subsequent painting.[7] It may be that this transformation was a deliberate refinement to give the socially privileged view from the *piano nobile*, the first floor of a

12 *Grand Canal: looking North from near the Rialto Bridge*, 1725. Pen and brown ink on paper, 175 x 285 mm. Private collection.

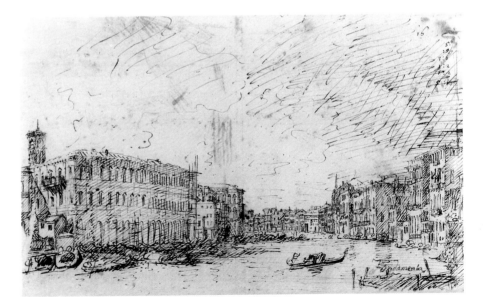

palazzo, which housed the grandest rooms. It is possible that some patrons may have wanted this, but whether this was indeed Canaletto's motive or whether it was a purely aesthetic adjustment is a matter for speculation.

In addition to the sketches and more elaborate *in situ* views that we have seen so far, Canaletto would also make compositional drawings in the studio when planning paintings. Only a few of these survive, but there is a set for the celebrated series of six paintings of the Piazza San Marco and the Piazzetta painted for Consul Smith in the late 1720s (now in the Royal Collection) which may have been produced for Smith's approval before the paintings were started.

We must assume that Canaletto's very highly finished drawings (for example, figs. 20 and 44) were at first produced exclusively for Joseph Smith since there is no evidence that anyone else was at all interested in Canaletto as a draughtsman in the 1730s, when many of these were made. One theory is that they were *ricordi*, mementoes of paintings that had passed through Smith's hands, perhaps produced by Canaletto as part of the agreement between them. Certainly many of them do correspond to known paintings that Smith handled. It is traditionally supposed that, for the most part, they were not preparatory drawings for paintings, but independent works of art. However, the question of how Canaletto proceeded from his rough sketches and rapid composition drawings to his astonishingly detailed paintings remains to be answered. Did he produce more detailed preparatory drawings such as these as a transitional step between the sketch and painting? Could some of Smith's drawings be preparatory studies after all? Canaletto's working method of transforming diagrammatic notes of Venetian buildings into the most meticulous renderings of architecture in European painting is far from clear.

One of the perennial questions relating to Canaletto's practice is whether or not he used a camera obscura (or *camera ottica*), a device which permitted the reduced projection of a city view on to a flat surface, to help him capture the image of Venice.[8] Antonio Maria Zanetti wrote that 'by his example Canal taught the correct way of using the *camera ottica*; and how to understand the errors that occur in the picture when the artist follows too closely the lines of the perspective'.[9] This and other less contemporary assertions have created a whole mythology around Canaletto and the camera obscura, to the extent that any distortions or manipulations of Venetian topography that appear in his work are ascribed to his use of the instrument. A further complication is the existence in the Correr Museum of a *camera ottica* which bears Canaletto's name but for which there is no other evidence at all that links it to the artist.

It is now generally agreed that Canaletto probably did make observations using a camera obscura, but that he only used it as an aid for drawing to a limited extent, if at all. It is certain that he could not have used one for any of his paintings or for his larger drawings – all of which were made in the studio. The only situation in which the use of an optical device may have been possible was for his small sketches. The most convincing example of a sketch that could have been traced under a projected image is that of

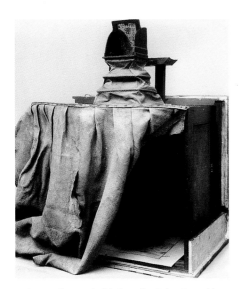

13 Camera obscura which belonged to Joshua Reynolds, London, The Science Museum.

S. Simeone Piccolo (see fig. 21), and the camera obscura would have to have been of the type that cast an image down on to a piece of paper while the viewer observed it under a light-excluding curtain. The best-known surviving instrument of this type is the one which once belonged to Sir Joshua Reynolds (fig. 13).

The attraction of suggesting that the S. Simeone Piccolo sketch was made using a camera obscura is that the drawing was clearly made from dry land across the Grand Canal. The practical difficulties of tracing an image with an optical device balanced precariously in a rocking boat on the Grand Canal are not to be underestimated – and, since many of the sketches in the Accademia sketchbook seem to be made from the water, it follows that they were probably mostly made freehand. Canaletto may indeed have enjoyed observing Venice frequently with a *camera ottica* but, in all likelihood, it played little practical part in the record he made of the city.

In the next five chapters we will be examining how Canaletto brought the topography of Venice on to the canvas and how he went about constructing the views which have become so familiar to us. Each chapter focuses on one or on a group of National Gallery paintings and a final chapter deals with the evolution of the artist's painting technique. Our exploration begins at the top of the Grand Canal at S. Simeone Piccolo, near the modern-day railway station, and will eventually bring us to St Mark's Square – Piazza San Marco – the very heart of the city.

S. Simeone Piccolo

WE ARE AT THE TOP of the Grand Canal looking south-west (fig. 15). Around the right-hand bend in the distance is the short stretch known in Canaletto's day as the Canale di S. Chiara, which leads to the open lagoon. The principal buildings shown are, on the left with the green dome, the church of SS. Simeone e Giuda, always known as S. Simeone Piccolo and, on the near right, the church of S. Maria di Nazareth, known as the Scalzi (the church of the barefoot friars).

On the left beyond S. Simeone Piccolo, at the start of the bend, is the simple pitch-roofed church of S. Croce, from which one of the *sestieri* (the six districts of Venice) of the city took its name. The bridge just before it is the Ponte della Croce – also known as the 'ponte della zirada' (bridge of the turn), because here was placed the post around which the gondoliers in the regatta turned to race back to the finish at the Volta del Canal (see p.31). On the right beyond the Scalzi are the church of S. Lucia and, just visible in the far distance, part of the church and convent of Corpus Domini. At the left is the stern of a *burchiello*, the passenger barge which plied between Venice and Padua, and which was always towed by another boat – a gondola or *sandolo* (a lower, flatter boat than a gondola) – when on the Grand Canal.

This view today is very different (fig. 16). S. Simeone Piccolo, the houses around it and the Scalzi remain – but little else does. On the left side of the Canal, S. Croce was demolished in 1810; all that remains of the church is an eleventh-century Byzantine-style column and capital built into the wall of the Papadopoli Gardens which now occupy the site. One building beyond S. Croce that has survived, now the Hotel Santa Chiara (fig. 14), was a *tintoria* or dyeworks in the eighteenth century and was the viewpoint for a drawing and paintings by Canaletto in the reverse direction, back towards our present position (see fig. 23). On the right side of the Canal, everything beyond the Scalzi was demolished in 1861 to make way for the railway station (replaced by the present modern structure in 1955) and railway administration offices. Immediately in front of the position occupied by the spectator, the Grand Canal is now crossed by the Scalzi bridge, built in 1934 to replace a nineteenth-century wrought iron bridge.

14 Detail of fig. 15 (*Venice: The Upper Reaches of the Grand Canal with S. Simeone Piccolo*).

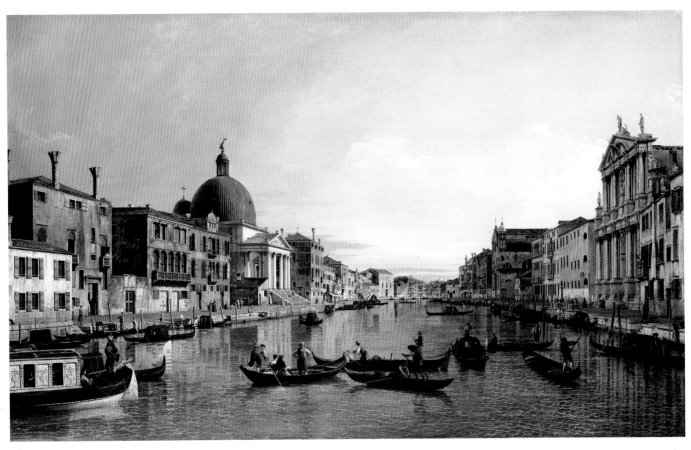

15 *Venice: The Upper Reaches of the Grand Canal with S. Simeone Piccolo*, 1738. Oil on canvas, 124.5 x 204.6 cm. London, The National Gallery.

16 Photographs of the upper reaches of the Grand Canal with S. Simeone Piccolo (left) and the church of the Scalzi (right), taken from the Scalzi bridge (photos Sarah Quill 1998).

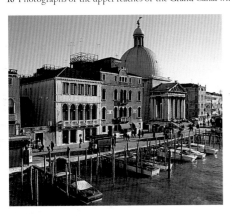
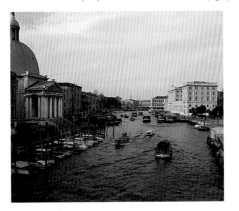
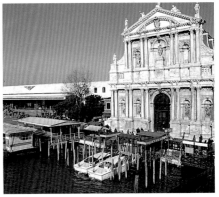

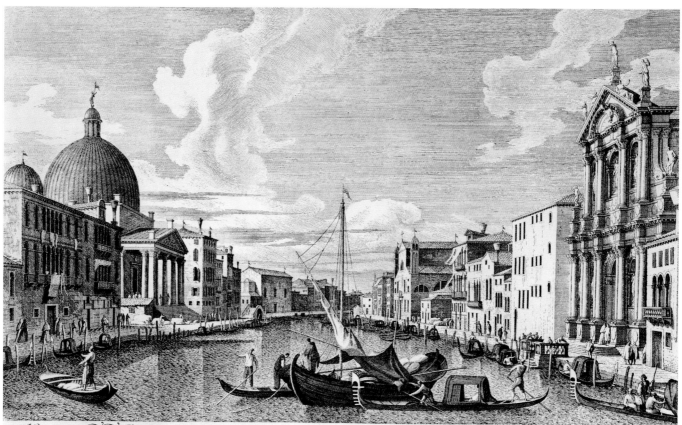

Hinc ex F.F. Discalceatorum Templo, illinc ex S.ᵗ Simeone Minore usque ad Fullonium. XI.

S. Simeone Piccolo was built in its present form between 1718 and 1738 under the architect Scalfarotto (*c.*1670–1764) and was consecrated in April 1738. Beside the steps of the church in Canaletto's painting is a workman's hut. In another painting by Canaletto of the scene (Royal Collection), which was engraved in 1735 by Visentini in his *Prospectus Magni Canalis Venetiarum* (fig. 17), the workman's hut also appears, but construction seems to be at a slightly earlier stage since several blocks of stone are lying about. It is reasonable to suppose, therefore, that the National Gallery painting can be dated after 1735; a date of just before April 1738, when the church was presumably completely finished, is generally accepted.

It is late afternoon in the painting: the sun shines from the west, obliquely illuminating the buildings on the left side of the Canal and picking out the relief of the façades beyond S. Croce. Light effects are beautifully observed. The right side of the Canal is in shadow, but tiles on a few roof-tops catch the low sunlight where it filters between the buildings (fig. 18). Figures walking in the shade in front of the Scalzi have

17 Antonio Visentini after Canaletto, *Grand Canal: looking South-West from the Chiesa degli Scalzi to the Fondamenta della Croce, with S. Simeone Piccolo,* 1735.
Engraving from the *Prospectus Magni Canalis Venetiarum (Urbis Venetiarum Prospectus Celebriores),* Venice, 1742 edition, part 1, plate XI.

shadows that at first seem illogical but are, in fact, due to light reflected from buildings across the Canal.

Although the viewpoint in the painting appears to be from a boat in the centre – or to the right of centre – of the Grand Canal, it is more likely that studies were made from dry land. Just before the Scalzi, the *fondamenta* juts out to accommodate some buildings (on the south side of the street known as the Lista di Spagna) and, in Canaletto's day, the entrance to a small looped side canal. This promontory has been smoothed out in Ughi's map but is clearly visible on the left side of a painting which shows the view from the other end, once attributed to Canaletto, but now given to an unknown Venetian painter of the eighteenth century (fig. 19). From this point, Canaletto could have sketched both banks more or less as they appear in the painting; but it is a view that cannot be recaptured today because the modern bridge intervenes.

No drawings of the scene from this angle survive, but Canaletto certainly drew it from other directions. A drawing at Windsor (fig. 20) shows S. Simeone Piccolo and the buildings on either side from directly across the Canal. A *burchiello* partly visible at the left of the drawing is being towed by a *sandolo* with four oarsmen. The sunlight comes from the front left and is presumably notional since this would be from the north-east. The familiar workman's hut is seen to the left of the church portico. However, construction of the church is at an earlier stage than in the National Gallery painting or the Visentini engraving since only the central part of the steps has been completed, with temporary wooden handrails on either side. This probably dates the drawing to before 1735 when the steps were apparently already full width (see fig. 17).

This drawing is one of what may have been intended as a series of views of Venetian churches which were in Consul Smith's collection. It is unlikely that they were made on

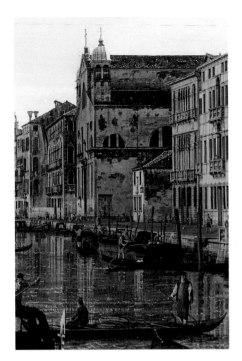

18 Detail of fig. 15 (*Venice: The Upper Reaches of the Grand Canal with S. Simeone Piccolo*).

19 Venetian School, 18th century, *The Grand Canal with S. Simeone Piccolo*. Oil on canvas, 94.3 x 145.4 cm. London, The Wallace Collection. The view is from the opposite direction of fig. 15. The small promontory on the left side of the Grand Canal, just beyond the Scalzi was the viewpoint for fig. 15. The campanile in the distance belongs to S. Geremia.

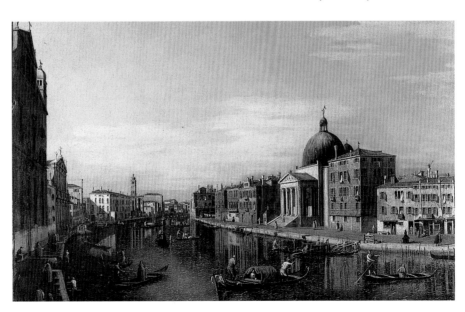

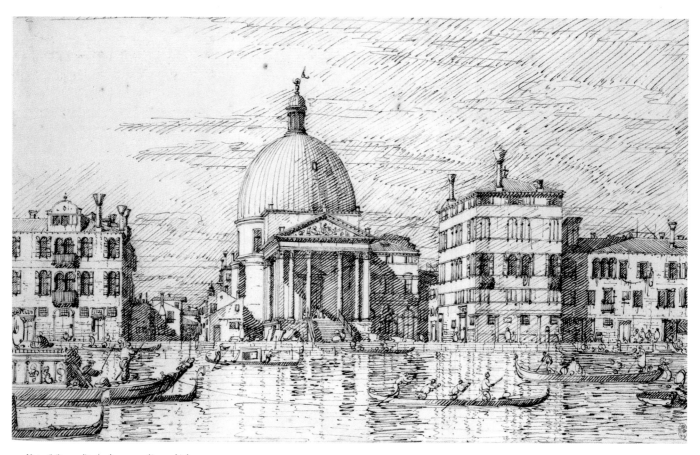

20 *Venice: S. Simeone Piccolo*, about 1730. Pen and ink on paper, 227 x 375 mm. The Royal Library, Windsor Castle. The Royal Collection © 1998 Her Majesty The Queen.

the spot, and they were probably put together from smaller sketches. Indeed, there is a sequence of four pages in the Accademia sketchbook which corresponds almost exactly with this larger drawing (fig. 21), including the house on the left, the Casa Adoldo, and the Palazzo Diedo-Emo on the right and only omitting part of the house at the extreme right. Significantly, the church is shown at the same stage of construction as in the Windsor drawing, with stone lying about for the next phase of work. On the steps is written *tola*, meaning 'wooden boards', indicating temporary wooden steps and handrails.

The sequence of sketches in the Accademia sketchbook is fascinating for what it reveals of Canaletto's working method. There are extensive annotations referring to the various parts of 'S. Simion picolo' and the surrounding buildings; colour notes are inscribed on several of the walls – *R* (for *rosso*, red), *Cn* (*cenere*, ash grey), *Zo* (Venetian form of *giallo* – yellow), *Rosso chiaro* (light red), *Rosso belo* (beautiful red) – and, on a shopfront towards the right, *quel di Loio* (*olio*, that is, oil vendor). One of the sketches may also contain a clue relating to Canaletto's use of the camera obscura: the dome of the church is too tall for the page and the upper part with its lantern has been drawn separately alongside. The fact that the two parts fit precisely if superimposed suggests that the projected image of an optical device may have been traced – and that the sketchbook page has simply been shifted under the image to accommodate the upper part. Dotted lines on the dome, with *vivo* (middle) *del Cupolin* written between them, indicate the position where the lantern is located.

Canaletto also drew the Grand Canal with S. Simeone Piccolo from the opposite direction to that shown in the National Gallery painting – from a viewpoint by the *tintoria*, where the Canal curves right towards the open lagoon. The original drawing is in

21 *Composite View of S. Simeone Piccolo and Neighbouring Buildings*, about 1730. Lead pencil, pen and ink on paper, each leaf 228 x 170 mm. Accademia Sketchbook, fols. 52v, 53, 53v, 54. Venice, Accademia.

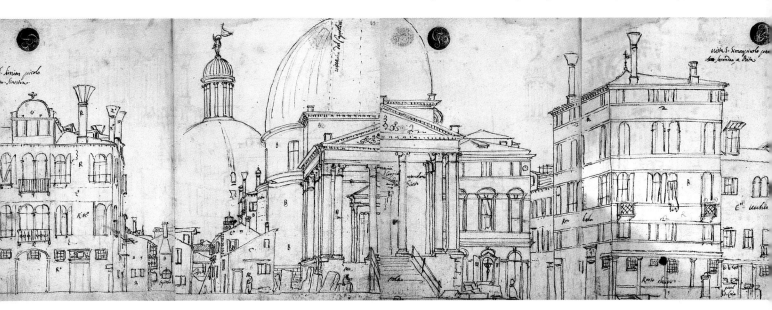

the Royal Collection at Windsor and is reproduced almost exactly in a painting in the National Gallery ascribed to a follower of Canaletto (fig. 23). Looking in this direction, the churches of Corpus Domini, S. Lucia and the Scalzi are seen along the left side of the Canal and the façade of S. Croce prominently in the right foreground. The dome and cupola of S. Simeone Piccolo can be seen above the houses in the distance. The campanile just to the left of the dome is that of S. Geremia, further along the Grand Canal on the opposite side. The ever-present *burchiello* at the near left is being towed by a four-man *sandolo*. The sun shines from the south.

This view, too, was pieced together by Canaletto from a series of four double pages (working right to left) in his sketchbook (fig. 22). They cover the entire width of the composition from the wall of the convent of Corpus Domini at the left to the complete façade of S. Croce at the right. The scale is not consistent in all four sections. The double page containing the dome of S. Simeone Piccolo is larger in scale than the others and not all the dome can be accommodated; the tiny portion of the dome seen on the next page is much smaller, correctly sized for the buildings stretching back from S. Croce. In the sketch, S. Croce is correctly shown as it was, with a narrow window above each of the side doors in the façade; in the Windsor drawing and in the painting copied from it, the two windows are omitted.

23 RIGHT Follower of Canaletto, *Venice: Upper Reaches of the Grand Canal facing S. Croce*, after 1768.
Oil on canvas, 59.7 x 92.1 cm.
London, The National Gallery.
The painting is derived from a drawing by Canaletto in the Royal Collection.

22 *Composite View of Buildings on the Grand Canal looking towards S. Simeone Piccolo*, about 1730. Lead pencil, pen and ink on paper, each leaf 228 x 170 mm. Accademia Sketchbook, fols.28v, 29, 27v, 28, 26v, 27, 25v, 26.
Venice, Accademia.

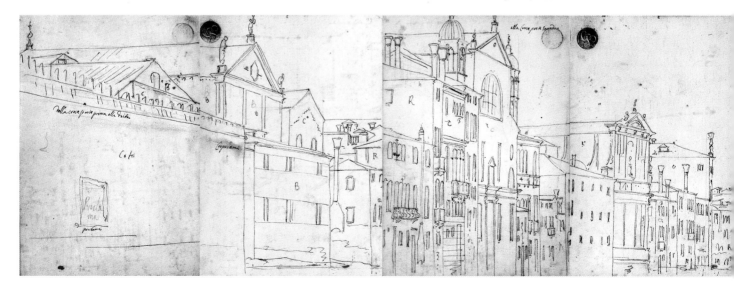

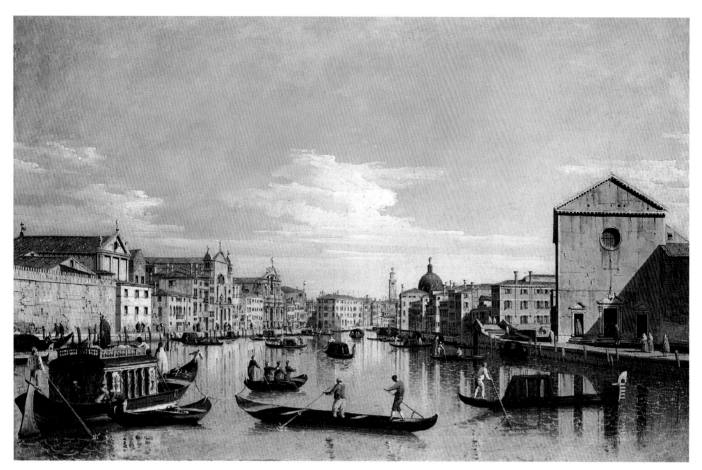

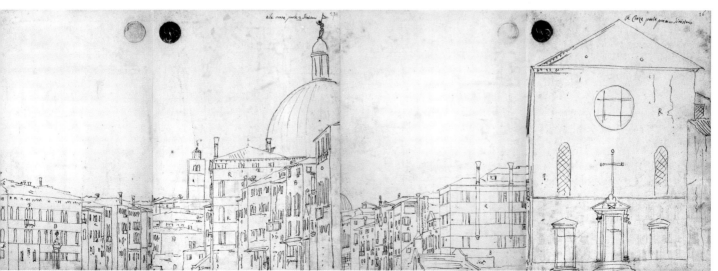

27

Regatta Scenes

THE LONGEST STRAIGHT STRETCH of the Grand Canal runs from the Rialto Bridge to the Volta del Canal, where it turns sharply and enters the elegant curve that leads one past S. Maria della Carità, the church seen in *The Stonemason's Yard* (fig. 42), and on to the Basin of San Marco. This stretch of the Grand Canal provided the principal setting for the regattas which so enthralled visitors to Venice at Carnival time. The view from Palazzo Foscari at the Volta del Canal back to the Rialto Bridge, a distance of some 800 metres, is one of the most splendid that Venice has to offer (fig. 24) and Canaletto painted it several times, both with and without regattas taking place, making it one of the canonical images of the city.

An early work (fig. 26), executed with the wispy brushstrokes and atmospheric sky typical of his work in the early to mid-1720s, shows a tranquil scene with gondolas criss-crossing the Canal, a *peota* with its scarlet awning forging through the water, and in the corner the *burchiello*, or passenger barge which we have seen several times already (figs. 15 and 20).[10] Almost all the buildings on the right side of the Canal are cast in deep shadow. The viewpoint adopted by Canaletto does, however, allow a clear view of the façade of Palazzo Balbi, the elegant palace on the left of the composition, built to the designs of Alessandro Vittoria in the 1580s. But if one compares it with the photograph one discovers that Canaletto has taken considerable liberties with the architecture, showing five arched windows on the central and upper storeys, and five corresponding round windows above them, when the building has only three. This is especially strange since in both his earlier and later views of the building he paints the façade with much greater accuracy. It is notable, too, that here, as in all his paintings of this particular view along the Grand Canal, Canaletto shows the buildings along the right bank sweeping

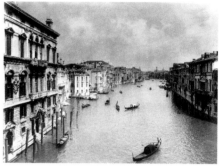

24 View from Ca' Foscari to the Rialto Bridge. Photograph by Osvaldo Böhm, Venice, about 1900. The Palazzo Balbi (left) had lost its obelisks at this date.

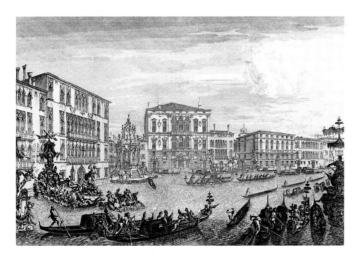

25 Michiel Giovanni Marieschi, *The Regatta at Ca' Foscari on the Grand Canal*, 1740/1, from the series *Magnificientiores Selectioresque Urbis Venetiarum Prospectus*, published in Venice in 1741 and 1742.
Etching, 312 x 463 mm (platemark).
London, The British Museum.

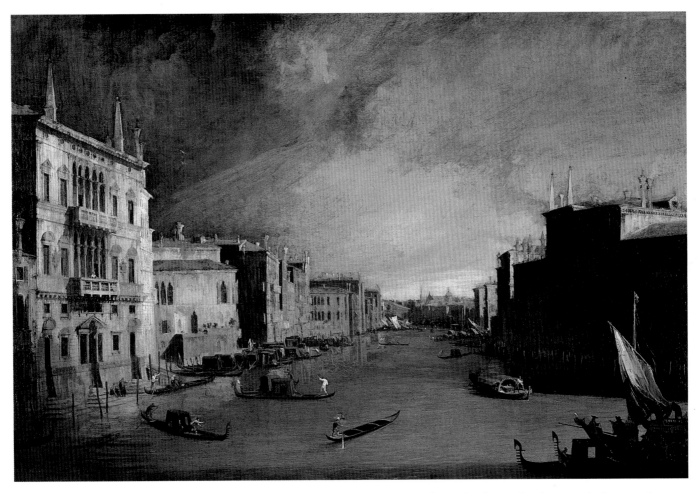

26 *Grand Canal: looking Northeast from the Palazzo Balbi to the Rialto Bridge*, early to mid-1720s.
Oil on canvas, 66.5 x 97.7 cm.
Hull City Museums and Art Galleries, Ferens Art Gallery.

round in an unbroken line to the Rialto Bridge, but as the photograph shows, and on-the-spot reconnaissance confirms, the buildings curve out of sight about half-way along. This minor modification to the topography of Venice serves to illustrate the artist's constant concern to improve or regularise a view in the interests of aesthetic effect without straying too far from perspectival truth.

Just to the left of Palazzo Balbi may be seen a house which runs along the tributary canal called the Rio di Ca' Foscari. This house is obscured in Canaletto's regatta views by the floating platform erected at the entrance to the Rio which supported the *macchina della regatta*, a temporary pavilion of painted wood, plaster and papier-mâché, from which the coloured pennants awarded to the victors were distributed. An etching by Canaletto's younger contemporary, Michiel Giovanni Marieschi (1710–43), shows how the *macchina* fitted between Palazzo Foscari and Palazzo Balbi, the latter now seen almost frontally (fig. 25). The regatta paintings by Canaletto in the National Gallery (figs. 27 and 28) show the *macchina* from the side; they are splendid examples of Rococo

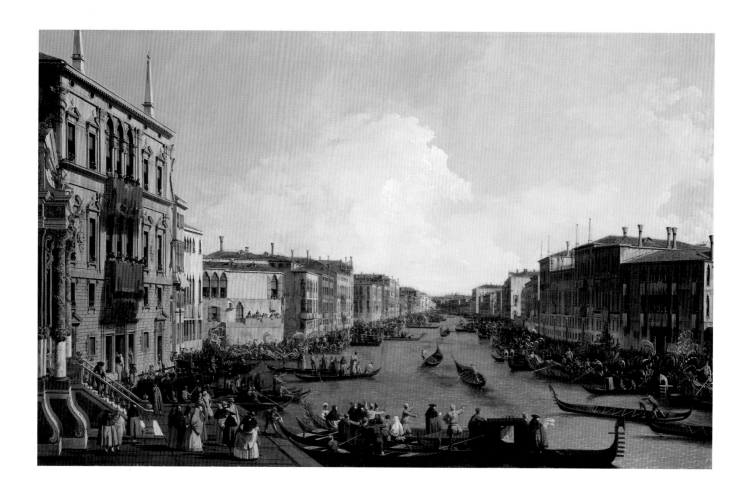

ephemera with delicately coloured and gilt pilasters and columns, and pediments laden with trophies, garlands and other ornaments.

The Venetian regatta has its origin in the fourteenth century as part of the celebrations which marked the Festa delle Marie (the feast of the Purification of the Virgin held on 2 February) and was usually held during the Carnival, which lasted from 26 December until Shrove Tuesday. In the foreground of both the National Gallery pictures several figures wear the *bauta*, a domino of white mask and black cape, which could only be worn at Carnival time. Special grand regattas were, however, sometimes laid on by the state outside the Carnival period in honour of distinguished visitors. One of these was held for King Frederick IV of Denmark in March 1709 and he enjoyed it so much that according to one commentator, 'he never stopped displaying the greatest pleasure and interest in the spectacle, of which he said it was impossible to conceive an adequate idea without actually having witnessed it.'[11] Frederick did take back to

27 *Venice: A Regatta on the Grand Canal*, about 1735.
Oil on canvas, 117.2 x 186.7 cm.
London, The National Gallery.
The painting came to the Gallery as part of the Wynn Ellis bequest in 1876.

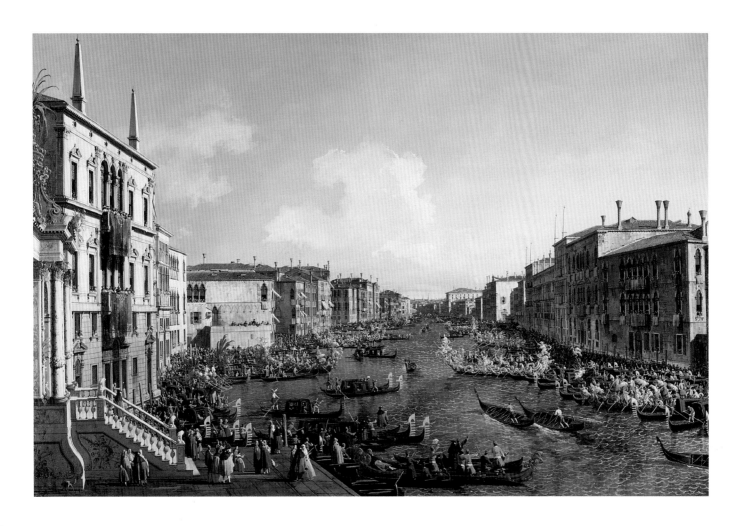

28 *A Regatta on the Grand Canal*,
about 1740. Oil on canvas, 122.1 x 182.8 cm.
London, The National Gallery.
The painting has a pendant showing *The Basin of San Marco on Ascension Day*, fig. 33. Both were bequeathed to the Gallery by Lord Revelstoke in 1929.

Denmark with him Carlevaris's large painting of the event which actually does give a very good impression of what the occasion must have been like (fig. 29). Carlevaris painted several versions of the composition and an engraving after it was made by G. Baroni. Canaletto's regatta scenes essentially follow the pattern devised by Carlevaris.

The course of the regatta was from the Motta di S. Antonio on the Basin of San Marco (that is, where the Public Gardens now are) along the entire length of the Grand Canal to the Ponte della Croce (visible in fig. 15) and back to the Volta del Canal.[12] There were various kinds of races for different crafts and combinations of rowers, including one for women gondoliers, but both Canaletto's National Gallery paintings show the one-oared light gondola regatta at the stage when the boats have passed the *macchina* for the first time. Spectators cheer from every balcony and window and from the array of boats which line the Canal. These include gondolas and elaborately decorated *bissone*, eight or ten-oared boats belonging to prominent Venetian families which would be

specially fitted out for the occasion. Some are adorned with mythological figures or personifications, while others have an oriental theme. Several designs for *bissona* decoration by Tiepolo, Guardi and Piranesi have survived.[13] The noble owners recline in comfort on piles of silk and velvet cushions and their rowers are dressed in brilliantly coloured livery. The *bissone* would sometimes be required to go ahead of the racers to clear the way and the young nobles would kneel on their cushions and fire pellets of chalk dust at those who obstructed the route.[14] Canaletto must have made numerous drawings of the various kinds of boats which went up and down the Venetian canals, although not many of these survive (there are a few in the early pages of the Accademia sketchbook). Unlike Carlevaris, however, he was not in the habit of making small-scale oil sketches, largely from the life, of boats and boatmen like those in the Birmingham Museum and Art Gallery study (fig. 30).

Canaletto's earliest treatment of the Carnival regatta appears to be the work made for Joseph Smith (fig. 32). The *macchina* in that work bears the arms of Doge Carlo Ruzzini (1732–5) and the painting is datable to 1733–4. Both the National Gallery pictures bear the arms of Ruzzini's successor, Doge Alvise Pisani (1735–41), and presumably date from his period of office, although their style indicates that they must have been made some years apart. By contrast with the work in the Ferens Art Gallery (fig. 26), the rendition of the architecture along both sides of the Grand Canal is such that one can

29 Luca Carlevaris, *Regatta on the Grand Canal in honour of Frederick IV of Denmark*, 1709. Oil on canvas, 135 x 260 cm. Det Nationalhistoriske Museum på Frederiksborg, Hillerød.

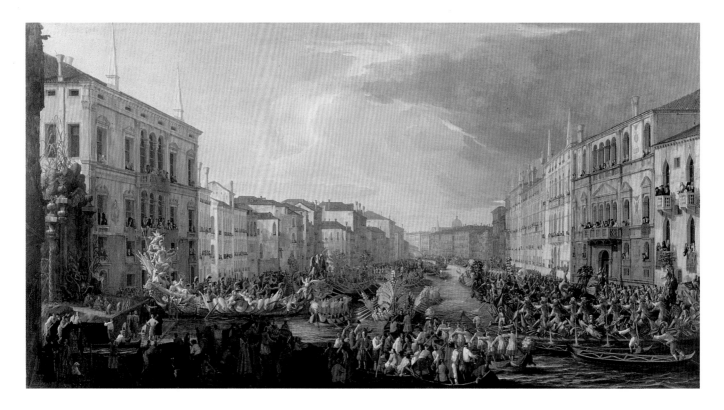

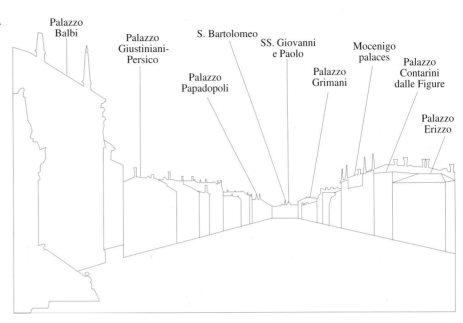

31 Diagram identifying the principal buildings in fig. 27.

Palazzo Balbi

Palazzo Giustiniani-Persico

S. Bartolomeo

Palazzo Papadopoli

SS. Giovanni e Paolo

Palazzo Grimani

Mocenigo palaces

Palazzo Contarini dalle Figure

Palazzo Erizzo

30 Luca Carlevaris, *Studies of Gondolas and Figures*, about 1710s.
Oil on canvas, 19 x 31.8 cm.
Birmingham Museum and Art Gallery.

identify the buildings relatively easily (fig. 31). The first building on the right is Palazzo Erizzo, followed by the Palazzo Contarini dalle Figure, the Mocenigo palaces surmounted by four obelisks and in the distance the massive pile of Palazzo Grimani, the masterpiece of the Veronese architect Michele Sanmicheli (1484–1559). On the left side, beyond Palazzo Balbi, one can see the side elevation of Palazzo Giustiniani-Persico, which Canaletto treats rather differently in the two works; much further down and also crowned with obelisks is Palazzo Papadopoli. In both the National Gallery paintings the skyline just to the right of the Rialto Bridge is punctured by the pointed campanile of the church of S. Bartolomeo and the roof and dome of SS. Giovanni e Paolo. The relationship between these distant buildings is reversed in the two paintings, however, and a comparison with the photograph of the view (fig. 24: which shows the reconstructed campanile of 1754) indicates that the more accurate one is the painting of 1735 which came to the Gallery as part of the Wynn Ellis Bequest in 1876 (fig. 27).

This picture, which is usually dated to the beginning of Pisani's reign, that is, about 1735, is painted with a broad and slightly bland touch, suggestive of a certain hurry in execution. The viewpoint is low and the foreground boats and figures are consequently quite large. In the other National Gallery regatta picture (fig. 28), which comes from the Revelstoke collection and is dated to the end of Pisani's reign, about 1740, Canaletto has shifted the viewpoint both upwards and further back. This may be seen by focusing on the course of masonry which aligns with the bottom of the first balcony of Palazzo Balbi. In the earlier (Wynn Ellis) picture it inclines downwards towards the vanishing

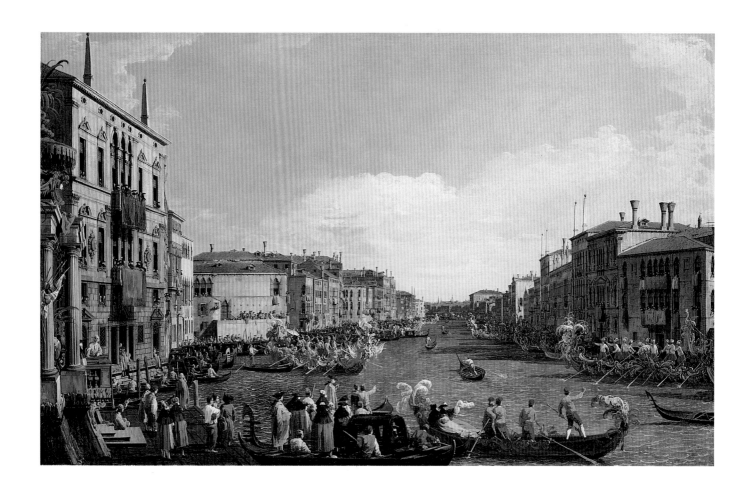

point, which Canaletto has fixed just to the right of the Rialto Bridge, indicating that the viewer is seeing it from below. In the later (Revelstoke) picture it is perfectly horizontal and parallel to the top and bottom edges of the picture, indicating that the notional position of the viewer has risen to that level. The resulting effect is that we have the impression that in the latter work we are viewing a much broader panorama and Canaletto strengthens the effect by making the boats and the figures in the foreground much smaller; indeed when one looks carefully at the figures, some, like those beside the stairs on the *macchina*, seem too small. In fact, the angle of vision adopted in both paintings is practically identical. As we have seen, Canaletto would often raise the viewpoint between preparatory drawing and painting; it is less common to find the adoption of this pattern between similar paintings. The significant difference between the two regatta views, which helps to explain why Canaletto treated them the way he did,

32 *A Regatta on the Grand Canal*, 1733–4.
Oil on canvas, 77.2 x 125.7 cm.
Windsor Castle, The Royal Collection
© 1998 Her Majesty The Queen.

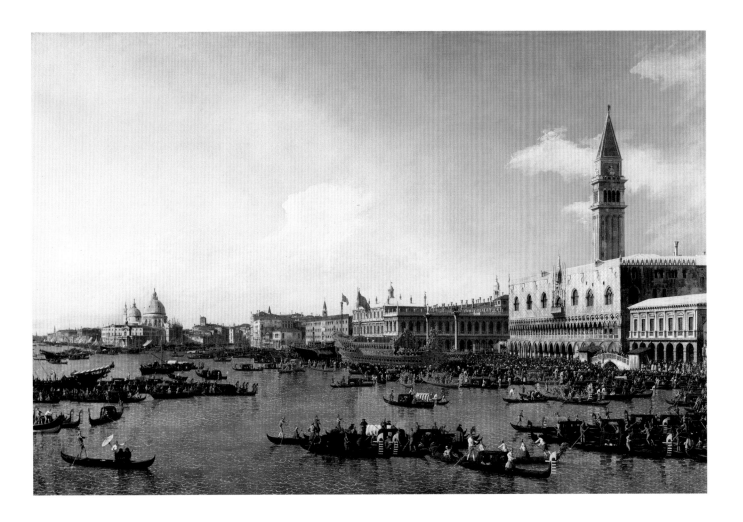

33 *Venice: The Basin of San Marco on Ascension Day*, about 1740.
Oil on canvas, 121.9 x 182.8 cm.
London, National Gallery.
The painting is a pair to *A Regatta on the Grand Canal*, fig. 28.

is that the Revelstoke picture was painted as a pendant to another work which does indeed show a much vaster view, *Venice: The Basin of San Marco on Ascension Day* (fig. 33). This painting embraces the whole expanse of water in front of the Doge's Palace.

When painting on such a large scale Canaletto acted rather like a composer scoring a work for a large orchestra and within the confines of an elaborate perspectival structure kept in play, and in equilibrium, a wide range of motifs and effects.

Venice: The Feast Day of Saint Roch

Having reached as far as the Volta del Canal we now step on to dry land and make a detour to the area behind Palazzo Balbi. After taking a few sharp turns we find ourselves near the great Franciscan church of S. Maria Gloriosa dei Frari which houses Titian's *Assumption*. A few moments later we are in Campo San Rocco.

Every year on 16 August, the feast day of Saint Roch, the ducal galley would convey the Doge of Venice to the church of S. Rocco, where the saint's relics are revered. He would attend mass together with the members of the Venetian Senate, the nobility and the ambassadors, after which it was customary for him to visit the nearby Scuola Grande di San Rocco, the seat of one of the city's most important lay confraternities devoted to charitable works. There he would be shown some of the Scuola's precious collection of relics and could observe the great canvases of Tintoretto. The tradition of the solemn visitation was established after the great plague of 1576, when the saint's intercession was held to have prevented the city's population from being decimated. Saint Roch was declared a patron of Venice and 16 August a feast of the Republic. The particular mix of religious devotion and political display was characteristic of Venetian state ceremonies and served both to bind together the various institutions of the Republic and to impress upon the ambassadors and foreign visitors the splendour and dignity of Venice.[15]

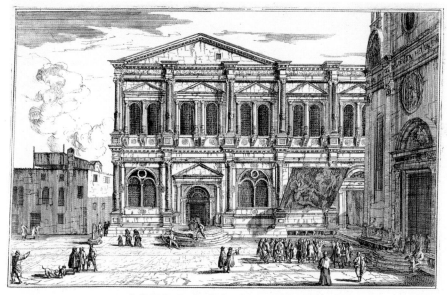

SCVOLA DI S. ROCCO

Architettura di Sebastiano Serlio

Luca Carlevarijs del. et inc.

34 Luca Carlevaris (1663–1730), *The Scuola di S. Rocco*, engraving from *Le Fabriche, e Vedute di Venetia*, published in Venice in 1703. Etching, 203 x 289 mm (platemark). London, The British Museum. The façade of the Scuola was designed by Antonio Scarpagnino and not by Serlio as the etching states.

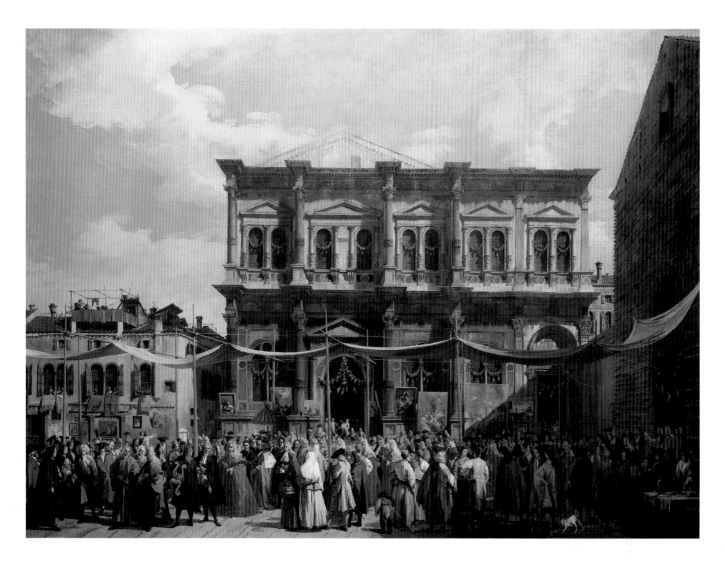

35 *Venice: The Feast Day of Saint Roch*, about 1735.
Oil on canvas, 147.7 x 199.4 cm.
London, The National Gallery.

Canaletto's record of this event in the Venetian state's ceremonial calendar is one of his largest and most memorable works (fig. 35). Although Carlevaris had made an engraving of the church and Scuola di San Rocco in his *Fabriche, e Vedute di Venetia* of 1703 (fig. 34), Canaletto seems to have been the first painter to make the ceremony itself the subject of a picture. The dignitaries are shown processing out of the church under the shade of a specially erected canvas awning. The Doge, in his state robes of gold and ermine and wearing the cap and rensa (head-cloth of white linen) of his office, his parasol held aloft behind him, is preceded by three secretaries in mauve garments, his chair- and cushion-bearers, and the Cancelliere Grande (Grand Chancellor) in scarlet. On his right is the Guardiano Grande of the confraternity and on his left the doyen of the ambassadors. Behind him is carried the sword of state and in the train are the scarlet-

robed senators accompanied by the ambassadors in civil costume. Several figures carry nosegays which were presented to them by officials of the Scuola as a symbol of protection against the plague. A small crowd of onlookers has gathered and Canaletto, whose considerable gifts as a painter of genre often pass unremarked, shows market vendors – one of whom holds weighing scales – who have abandoned their baskets of produce while the procession passes, a ragged beggar with his boy and between them a pair of visitors from the Near East, and a sprightly dog who sniffs at a man's shoe. The features of the Doge are not sufficiently distinctive for him to be certainly identified but he bears some resemblance to portraits of Doge Alvise Pisani who reigned from 1735 to 1741.[16]

When Canaletto painted *The Feast Day of Saint Roch* in about 1735, the church of San Rocco had no façade. The façade shown in the engraving by Carlevaris had been removed as unsafe, probably by 1727, and the one which can be seen today was erected by Bernardino Macaruzzi in the second half of the 1760s (fig. 39).[17] Gabriel Bella's painting of the Doge's visit to the church and Scuola of San Rocco, which dates from the 1780s (fig. 36) shows Macaruzzi's façade; it also illustrates a different arrangement for the awning, with the procession making its way from the church directly into the Scuola. In another of his painted views of Campo San Rocco (Italy, Private collection), Canaletto showed San Rocco with a façade with a classical pediment and attached columns but this was almost certainly his own invention. The engraving made by Visentini after this

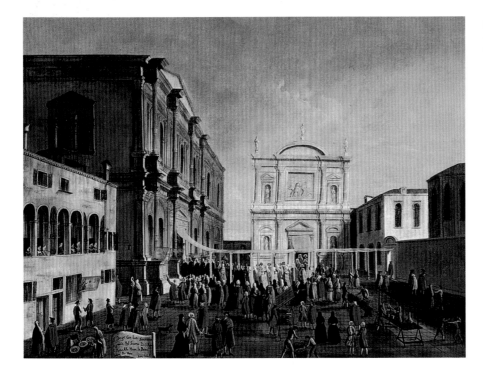

36 Gabriel Bella (1730–1799), *The Doge's Visit to the Church and Scuola of San Rocco*, signed, 1780s. Oil on canvas, 92.5 x 145.5 cm. Venice, Fondazione Querini Stampalia.

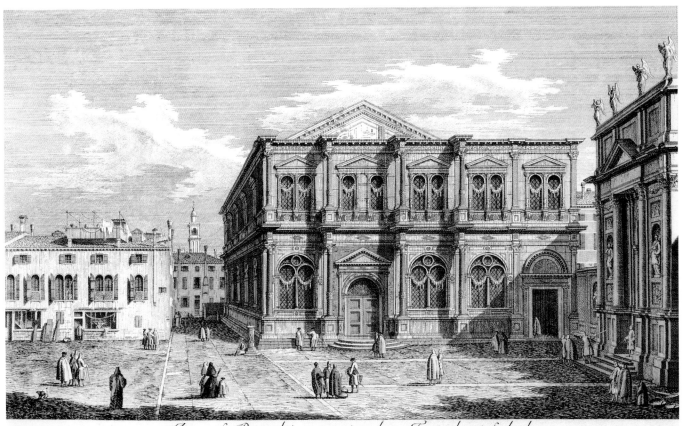

Area S. Rocchi cum ejusdem Templo et Schola.

V.

37 Antonio Visentini after Canaletto, *Campo San Rocco.*
Engraving from the *Prospectus Magni Canalis Venetiarum*
(*Urbis Venetiarum Prospectus Celebriores*),
Venice, 1742, part III, plate 5.

painting presents an even more elaborate façade (fig. 37). Michiel Giovanni Marieschi imagined a fanciful Baroque façade of his own in his etching of about 1740 (fig. 38).

It is the façade of the Scuola itself, however, the lavish and elegant masterpiece of Antonio Scarpagnino (1465/70–1549), which is the main focus of the painting, occupying nearly half the picture space. Canaletto has executed it with great precision, making plentiful use of the ruler and compass. The sunlight falls from upper right – causing a large triangular shadow to fall across the lower right-hand portion of the Scuola – and plays across the façade, picking out the delicately coloured marble inlays, the sculpted columns and capitals, and creating warm shadows, some of them inexplicably ragged, like those beneath the upper cornice.

Although the rendition of the architecture itself is accurate, Canaletto's view is at least partly fiction. The sun, which according to the direction of the shadows is due north, is never in this position.[18] More significantly, the viewpoint he has adopted is impossible. The Campo on which the Scuola stands is no more than twenty metres wide

39

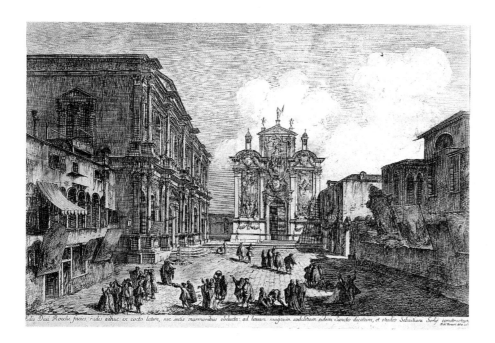

Edis Dui Rocchi facies, rudis adhuc ex cocto latere, nec sectis marmoribus obducta: ad levam nugrum sodalitium eidem Sancto dicatum, et studio Sebastiani Serly constructum.

38 Michiel Giovanni Marieschi, *Campo San Rocco*, about 1740, from the series *Magnificientiores Selectioresque Urbis Venetiarum Prospectus*, published in Venice in 1741 and 1742. Etching, 312 x 471 mm (platemark). London, The British Museum.

(see fig. 39) and it is simply not possible to have the broad open view of it that Canaletto has represented. Both the Marieschi print and the painting by Gabriel Bella (which is based on the print) show the view down the Campo towards the church and give a clearer idea of the narrow dimensions of the space. Canaletto has shown the church façade set back from the right edge of the Scuola but in fact it projects several metres in front of it. Furthermore, if one compares the scale of the figures in the procession with that of the onlookers who stand in the two doorways of the Scuola, it is clear that Canaletto implies a far larger space between the Scuola and the processional route down the middle of the Campo than is physically possible. In accordance with the conventions of view painting the obstacles of the near-side space dissolve as in a theatre to give the spectator the privileged view of the site. Topographical accuracy has been quite seriously compromised but Canaletto's representation is utterly persuasive within its own terms. In a third painting of San Rocco (fig. 40), Canaletto showed the Scuola from a viewpoint further down the Campo so that one sees some of the side elevation but here too the Campo is shown as much wider than it is in reality.

On the occasion of the feast day of Saint Roch the façade of the Scuola would be hung with pictures by old and contemporary masters and Canaletto shows them on the front of the nearby houses too.[19] Marieschi's etching shows that some very large paintings with elaborate frames were hung on the wall which enclosed the small garden at the rear of the Frari. These paintings would be lent by collectors and also by artists anxious to give their works a public airing and perhaps find a buyer. Piazzetta, Tiepolo,

Sebastiano Ricci and Bellotto all exhibited works there and Canaletto himself is recorded as having displayed there in 1725 a view of SS. Giovanni and Paolo, which was immediately bought by the Imperial ambassador, who presumably had seen it after taking part in the procession.[20] Canaletto has been at pains to make none of the paintings readily identifiable but it is possible to recognise religious and historical pictures, as well as portraits, view paintings and landscapes. The painting on the far right looks to be a work by Canaletto and resembles a Grand Canal view like the painting in the Ferens Art Gallery (fig. 26). To the left of the largest picture on view is a painting that recalls the composition (in reverse) of Johann Liss's celebrated altarpiece of *Saint Jerome with the Angel* in the Venetian church of S. Nicola da Tolentino, and the painting to the left of it recalls the fancy portraits of Sebastiano Mazzoni (about 1611–78). Canaletto shows several figures deeply absorbed in examining the paintings.

Canaletto only painted the Doge's visit to S. Rocco once. The subject was not included in the set of twelve drawings of the *Festivals of the Doge* which he made in about 1763 and which were engraved by Giovanni Battista Brustolon (1712–96). The early history of the National Gallery painting is unknown but the earliest reference to it in a sale catalogue of 1802 states that it came 'from the Vatican'.[21] This is intriguing and may be inaccurate but it is tempting to think that it might have come from the collection of a Venetian Pope, for example Clement XIII Rezzonico (1758–69).

39 Photograph of the Campo San Rocco, the Scuola on the left and the church, centre.

40 *Scuola di San Rocco*, about 1733–6.
Oil on canvas, 47 x 80 cm.
Duke of Bedford, Woburn Abbey.

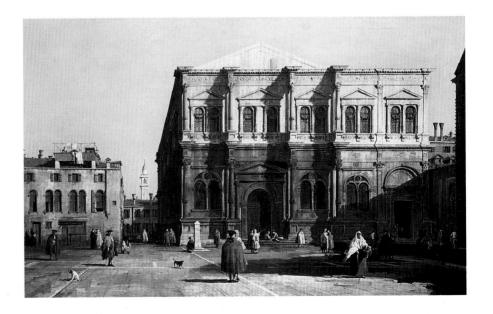

'The Stonemason's Yard'

W<small>E HAVE CONTINUED</small> our journey along the Grand Canal a short distance south-eastwards from the Volta del Canal and arrived at the scene of one of Canaletto's most celebrated paintings, known universally by its popular name, *The Stonemason's Yard* (fig. 42). The view is from Campo San Vidal across the Grand Canal to the campanile and north side of the church of S. Maria della Carità, with the façade of the Scuola della Carità in its shadow to the right. In the background on the right, the top of the façade and the campanile of S. Trovaso can be seen. On the near side of the Canal, large blocks of stone are scattered across the Campo, in the process of being cut and shaped by workmen whose wooden hut is seen at the right. In front of the open door of the hut a woman draws water from a well; at the left, a mother rushes to her crying child who has fallen backwards and a woman peers over the balcony above to see what the commotion is about. On the balcony of the house at the right, a woman sits spinning yarn in the early morning sun shining from the east. In the left foreground a cockerel crows.

Although it is recognisably the view seen today (fig. 41), in many respects the scene has changed substantially; it is now dominated by the wooden Accademia bridge that crosses the Grand Canal at this point, its far end touching down where the two small houses are shown in Canaletto's painting. The church façade – seen side-on here – no longer has its pinnacles, and the façade of the Scuola was replaced around 1760. The church and Scuola now house the Accademia gallery. The most dramatic change is the absence of the campanile, which fell down (also destroying the two white houses) in Canaletto's lifetime – in May 1744, two years before his move to England – and was not rebuilt.[22] In the April of the following year, 1745, Canaletto drew the campanile in Piazza San Marco under repair (fig. 50), but he appears to have made no record of the appearance of S. Maria della Carità without its campanile. The campanile of S. Trovaso lost its domed top at some point after *The Stonemason's Yard* was painted and that was also not replaced.

The Campo that appears in the foreground of the painting is the uneven field of mud, grass and stone that all Venetian *campi* originally were. Nowadays it is paved and, at least at the right, has changed little since Canaletto painted it. The house at the right still stands, although it has gained an additional storey, and the smaller house beyond with its chimney stack between two windows is also there, slightly extended to incorporate the lower sloping roof that, in the painting, separates it from the larger house. Behind the workman's hut a little canal runs into the Grand Canal and a small bridge can be seen at the left end of the hut. There is still a bridge at this point and, hidden behind the hut, leading directly to the house at the right, there is another bridge which stood in Canaletto's day and is still there. Remarkably, the same well-head from which the

41 Photograph of Campo San Vidal and Santa Maria della Carità (photo Sarah Quill 1998).
The eighteenth-century façade of the Scuola della Carità is hidden behind wooden shuttering to the right of the trees.

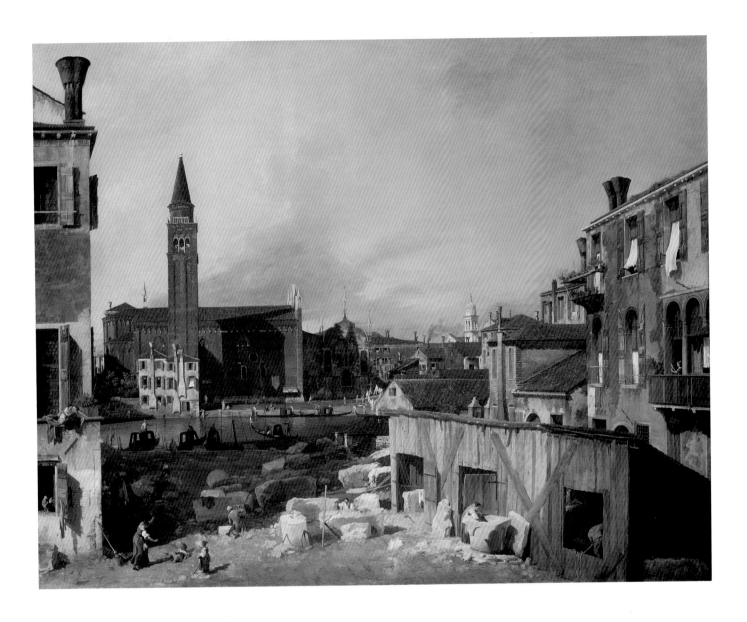

42 *Venice: Campo S. Vidal and Santa Maria della Carità*
(*'The Stonemason's Yard'*), 1727–8.
Oil on canvas, 123.8 x 162.9 cm.
London, The National Gallery.

woman draws water in the picture still exists at the centre of the Campo. The house at the left of the painting no longer stands: it was demolished in the nineteenth century to provide a garden for the adjacent Palazzo Cavalli (now Palazzo Cavalli-Franchetti).

The Stonemason's Yard is generally considered to represent the culmination of Canaletto's early career and, by many, to be his masterpiece. Yet in some ways it remains a mysterious painting – no drawings survive from this viewpoint, the date of the painting is uncertain and nothing is known of its early history – in fact, nothing of its history is known until it was recorded in the collection of Sir George Beaumont in 1808. It is probable that the stone-working depicted is connected with the rebuilding of the church of S. Vidal (which stands behind the spectator), but since this appears to have continued over a number of years, it does not help with precise dating. On stylistic grounds, a date before 1730 is usually accepted: on technical grounds, it seems unlikely to be later than about 1727–8 (see pp. 54-5). As Michael Levey has written, 'part of the difficulty of dating [the picture] is due to its uniquely high quality. It is perhaps the product of a moment of fusion between Canaletto's early and mature styles, both of which seem present in it.' [23]

Canaletto seems to have been reasonably faithful to the scene in front of him. As usual, he adopts a somewhat elevated viewpoint, on a level with the first-floor balconies, but he does not appear to have altered topography significantly or to have combined different viewpoints here. Although this view is unique in Canaletto's work, he drew and painted elements within this scene from other angles. There are paintings of S. Maria della Carità, seen from the west, showing the wide view past the church to the dome of the Salute and across the Grand Canal to the buildings beyond the Campo San Vidal. The version now in the Royal Collection (fig. 43), painted in the early 1730s and engraved by Visentini in his *Prospectus Magni Canalis Venetiarum* of 1735, shows the façade of the church head-on, with its elaborate crockets (a detail omitted from *The Stonemason's Yard*) and pinnacles, and the campanile somewhat diminished by perspective. We can now see that the campanile is separated from the nave of the church by a lower structure, probably a house, and that the white houses directly adjoin the campanile. The pinnacle on the Scuola casts a shadow on the centre of the church façade and the church casts a shadow on the base of the campanile: here, the sun shines from the south.

Across the Grand Canal in the Royal Collection picture, the house on the extreme left is the one whose back we see at the left of *The Stonemason's Yard*. To the right of it, smoke and the prows of two gondolas indicate that this is a *squero*, or boat-builder's yard, which indeed it was. Both house and yard were swept away in the nineteenth century to make the garden for the Palazzo Cavalli-Franchetti, the next building along. Beyond are the Barbaro palaces, the setting for Henry James's *The Wings of the Dove*, and the last building visible on the far bank is the side of the Palazzo Corner della Ca' Grande.

Although the Royal Collection picture itself is not large, it is conceived as a wide panorama, impossible to reconstruct nowadays because the bridge and waterbus station intervene, the canal in the foreground has been filled in, and it is impossible to stand far enough back without colliding with the wall of the building which now houses the

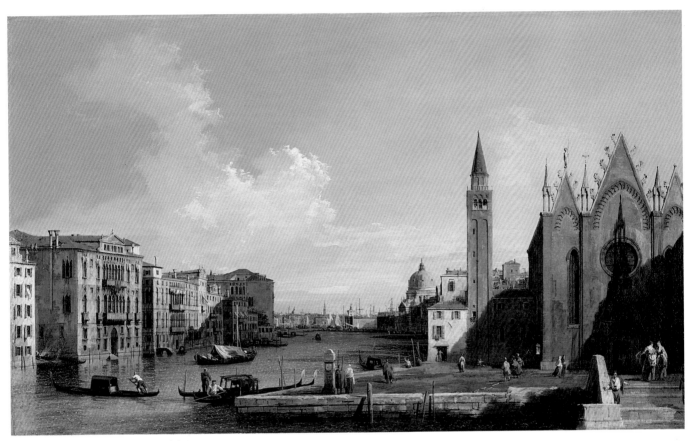

43 *Venice: The Grand Canal from the Carità towards the Bacino,*
early 1730s.
Oil on canvas, 47.9 x 80 cm.
Windsor Castle, The Royal Collection © 1998
Her Majesty The Queen.

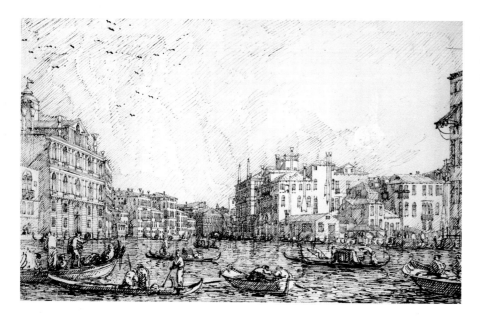

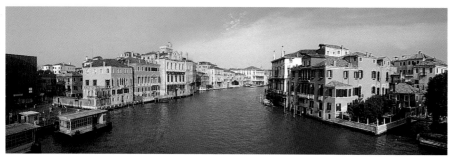

45 View up the Grand Canal towards the Volta del Canal (photos Sarah Quill 1998). The water-bus station at the left is adjacent to the Scuola della Carità. The white palace, centre left, is Palazzo Contarini degli Scrigni, which appears at the left of fig. 44. At the right is Campo San Vidal.

British Consulate. In fact, the view of the far side of the Grand Canal is an impossible one. From this point, in front of the façade of the Carità, the opposite bank curves rapidly out of sight and the palaces beyond Palazzo Cavalli-Franchetti can hardly be seen. Canaletto has shown them as if from a viewpoint beyond the Carità, expanded the field of view sideways and diminished the vertical scale, especially at the right. As with many of his Grand Canal views, he has mapped the two sides from multiple viewpoints. The result is utterly convincing because the individual details are accurate: only by trying in vain to match the painting with reality does the extent of Canaletto's manipulation of topography become clear.

Campo San Vidal, shown in *The Stonemason's Yard*, appears again in one of the highly finished drawings that Consul Smith acquired from Canaletto (fig. 44). The viewpoint here is apparently from a boat with S. Maria della Carità off to our left, looking up the Grand Canal and across to the Campo. The group of buildings on the far side of the

Campo is recognisably that seen at the right side of *The Stonemason's Yard* — the small house with its chimney stack between two windows separated by a lower sloping roof from the larger house on the right, and the long low warehouse along the side of the Grand Canal with the small square window in its gable end. The stonemasons' hut is no longer there and the little side canal that it concealed in the painting is now visible, together with the bridge that we could see partially beyond the hut and the one that was hidden. The house at the extreme right edge of the drawing is the house at the left side of the painting.

The view up the Grand Canal is of the gentle curve that precedes the sharp rightward turn of the Volta del Canal. The furthest palace visible on the left side is Palazzo Rezzonico where Robert Browning died. Begun by Baldassare Longhena in the mid-seventeenth century for the Priuli-Bon family, it had been built only as far as the *piano nobile* when this drawing was done and appears here covered by a temporary pitched roof (also shown in fig. 5); the final storey was not completed for the new owners, the Rezzonico family, until 1756.

In the Royal Collection drawing, Canaletto has rearranged the Grand Canal more than usual. If the Campo San Vidal were viewed from this angle, the church and Scuola of S. Maria della Carità would certainly be visible at the left. The first complete building shown on the left, Palazzo Contarini degli Scrigni, appears to be opposite the Campo but is, in reality, some way up the Grand Canal towards the bend (fig. 45). Again, Canaletto must have drawn the two sides of the Canal from quite separate viewpoints.

That Canaletto did indeed study these buildings in separate groups is confirmed by three consecutive double-page spreads of the Accademia sketchbook (fig. 46) which show the right side, centre and left side of the scene in that order — one of the cases in which Canaletto illogically constructed his panorama from right to left. The little tower on the Palazzo Contarini degli Scrigni, too tall for the page, has been drawn separately on the next sheet. Put together, the three double pages do appear more or less continuous, but differences in scale between sheets and obvious shifts of viewpoint have resulted in the architecturally meticulous but topographically inaccurate composition of the Windsor drawing.

46 *Composite View of the Lower Reaches of the Grand Canal looking towards the Volta del Canal, with Palazzo Contarini degli Scrigni on the left*, about 1730.
Pencil, pen and ink on paper, each leaf 228 x 170 mm.
Accademia Sketchbook, fols. 16v, 17, 15v, 16, 14v, 15.
Venice, Accademia.

Piazza San Marco

The Campanile of San Marco, at just under a hundred metres in height, dominates the Venetian skyline. Crowned with a large gilded statue of an angel which rotates with the wind, it served as a beacon to seafarers and it presides over the magnificent cluster of buildings and open spaces which constitute the heart of Venice and the principal destination of every visitor to the city: the Molo and the Piazzetta near the water's edge, the Doge's Palace and the State Library, the basilica of S. Marco and the great piazza, the only open space in Venice to bear this name (the others are *campi*). Here is the seat of the Republic's ancient government and the city's most sacred church where the relics of Saint Mark the Evangelist, patron of Venice, are kept. The piazza provided the setting for the city's most sacred and splendid spectacles, as the great canvases of Gentile Bellini show.

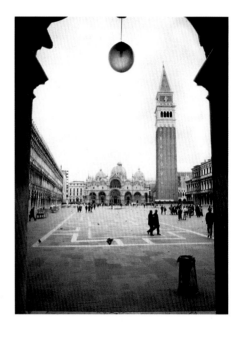

47 View of Piazza San Marco from the north-west corner.

In 1760 the Reverend John Hinchcliffe was in Venice accompanying the young John Crewe, later the first Lord Crewe, as his tutor. One day, in the words of Hinchcliffe's grandson Edward, they 'chanced to see a little man making a sketch of the Campanile in St. Mark's Place: Hinchcliffe took the liberty – not an offensive one abroad, as I myself can testify – to look at what he was doing. Straightaway he discovered a master-hand and hazarded the artist's name "Canaletti". The man looked up and replied "*mi conosce*" [you know me]'.[24] The chance encounter led to the purchase of several works by the English visitors, including the drawing the artist was at work on.

Canaletto drew and painted the Campanile numerous times but it has been rightly observed that he almost never represented it with accurate proportions. It is nearly always shown as more slender and taller than it really is: the Campanile is actually just under eight times as high as it is wide at the base and Canaletto often paints it nine and on a few occasions closer to ten times as high. Sometimes he shows eight openings up the side for lighting the interior staircase (which is correct) and sometimes nine (figs. 48 and 49) and sometimes he moves them from the left side to the right.

On 23 April 1745 the Campanile was struck by lightning which tore away much of the brickwork along the north-east corner of the building. Fortunately it remained standing (although it was eventually to collapse completely in 1902) and Canaletto made a drawing of it showing the scaffolding and cradle which were erected for repairs (fig. 50). The drawing has the character of an accurate record made on the spot but it is actually an autograph copy, with some small variations, of a drawing that Canaletto almost certainly did make on the spot a few days after the event and which passed into the collection of Consul Smith.[25] The watermark on the British Museum drawing is of a type which is found only on Canaletto's English subjects and it is likely that this is a copy that he made in England of the original drawing which he must have brought with him.[26] While he was in England, between 1746 and 1755/6, he continued to paint

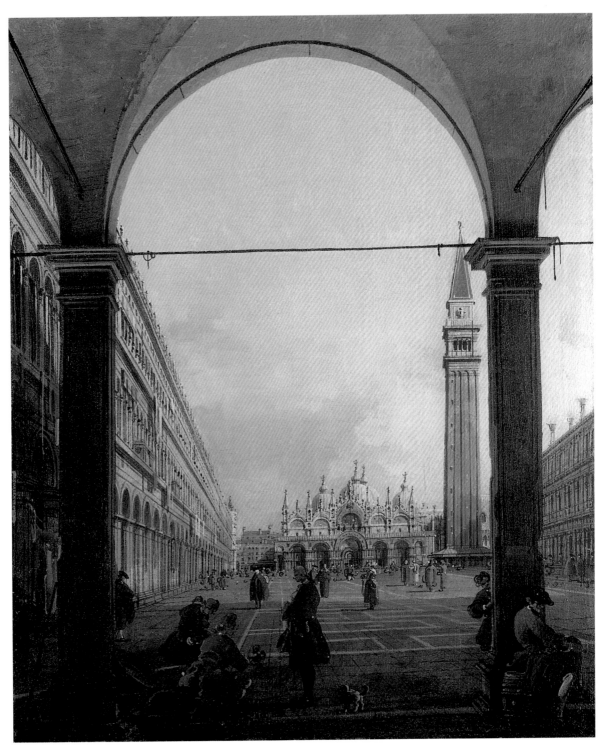

48 *Venice: Piazza San Marco*, late 1750s.
Oil on canvas, 46.4 x 37.8 cm.
London, The National Gallery.

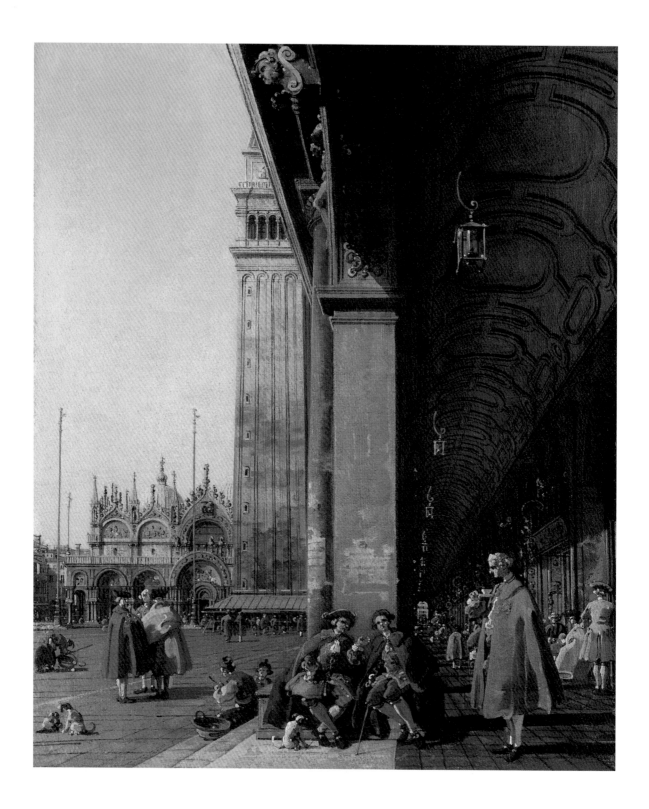

50

49 *Venice: Piazza San Marco and the Colonnade of the Procuratie Nuove*, late 1750s. Oil on canvas, 46.4 x 38.1 cm. London, The National Gallery.

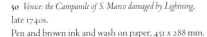

50 *Venice: the Campanile of S. Marco damaged by Lightning*, late 1740s.
Pen and brown ink and wash on paper, 451 x 288 mm. London, The British Museum.

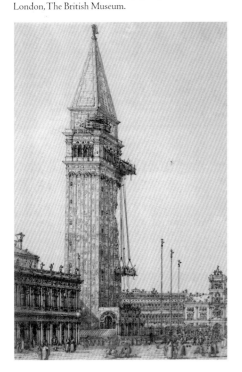

Venetian views and the existence of the two drawings acts as a warning not to be too dogmatic about where or when a picture might have been painted on the basis of the view alone.

The two small paintings in the National Gallery of Piazza San Marco are among Canaletto's most original views of the square. In both instances the view into the square is from underneath the arches which run along three of its sides, a device which allowed the artist to contrast the formal and semi-frontal views of the façade of the basilica and the Campanile with the steep perspective of the colonnades. The view shown in figure 48 is unique in Canaletto's oeuvre: there are no preparatory drawings, no other versions of the composition, and it is the only view of the square taken from the north corner. To the left we see the Procuratie Vecchie, which served as the official dwellings of the Procuratori of San Marco, the chief magistrates of the Republic, and on the right a section of the Procuratie Nuove, built between 1580 and 1640 and similar in design to the State Library in the piazzetta. The basilica is bathed in sunlight and quite accurately rendered, but curiously, for a painting that depends so much for its effect on the lining up of verticals, Canaletto has not painted the three tall flagpoles which stand in front of it, two of which do appear in the companion piece (fig. 49). In the shadowed foreground an ambulant vendor shows his wares to two gentlemen whose coats are painted with bold loaded strokes. Canaletto has deployed his artful dots and squiggles to enliven the square with people and give the surface of the painting variety and sparkle. The view is framed by the shadowed arch, a device he had already employed in the views of London in which he shows the city through the arch of the newly constructed Westminster Bridge. Bisecting the sky is the taut black line of the tie bar from which dangle thongs that once held garlands.

The arch from which Canaletto shows the view no longer exists in that precise form since the entire west end of the piazza, including the church of S. Geminiano which stood directly opposite San Marco, was demolished by Napoleon in order to build a palatial residence for himself (now the Correr Museum). Canaletto's arch corresponded exactly in design with those of the Procuratie Vecchie and had slimmer piers than those which have replaced it (fig. 47). Although Canaletto has elongated them slightly in this painting he has nevertheless managed to fit considerably more between them than would actually have been possible given the shallowness of the space behind the arch. He invested the Campanile with needle-like proportions and the perspective of the paving in the piazza was regularised to line up perfectly with the left-most arch of San Marco. As always with Canaletto, however, the view is entirely convincing.

The companion picture (fig. 49) shows the view from just inside one of the arches of the Procuratie Nuove on the east side of the square near Florian's famous Coffee House: the standing man daintily holds a cup and saucer in one hand to give us a clue that it is just off to the right. Although the views of the square and Campanile to the left and the colonnade to the right are both perfectly possible, they cannot both be seen from a single viewpoint because the arches are too narrow and the foreground pier would

obscure one of the views. Canaletto's solution is effectively to remove one of the piers and to double the width of the arch, thus making it possible to have the distance required for unifying the views. He brilliantly plays off the heavy relief of the spandrel sculpture with the clean lines of the Campanile on one side and the elegant arabesque of the lanterns on the other. The painting shows a quite masterly control of perspective, particularly in the receding ovals of the plaster work on the ceiling of the colonnade.

This painting is closely related to a drawing in horizontal format in Windsor which shows more of the square and includes the Clock Tower on the left and part of the Procuratie Vecchie (fig. 51). The Campanile is more cropped but one can see that originally it had been placed further to the left and then the artist changed his mind. This drawing and two similar drawings which are derived from it seem to date from before Canaletto's departure for London since none shows the additional storey which

51 *Venice: San Marco seen from the Arcade of the Procuratie Nuove,* about 1745. Pen and black ink with bluish-grey wash over pencil on paper, 193 x 284 mm.
The Royal Library, Windsor Castle.
The Royal Collection © 1998 Her Majesty The Queen.

was added to the Clock Tower in his absence and completed in about 1753. Canaletto has employed ruled lines and a compass for the arches of the basilica but the figures are executed in a lively freehand and the blue-grey wash is applied with great rapidity and confidence. Like all the Canaletto drawings at Windsor, this too was in the collection of Consul Smith.

Another drawing showing just the three foreground figures and the dog may be preparatory for the finished painting but may be intended as no more than a *jeu d'esprit* (fig. 52). It has the character of a cartoon and one is tempted to add irreverent captions. By contrast with Carlevaris, who made numerous drawn and painted figure studies, very few figure studies by Canaletto survive, although he must have made many of them, and this one is particularly attractive for the exuberance of the calligraphy. The drawing would appear to have been made with a broadly cut quill and as one follows the contours of the forms, the cloak of the standing figure for example, one can see the artist turning the pen to broaden or to thin the line. Similar calligraphic effects are apparent in the equivalent detail in the painting: a swiftly applied stroke of yellow marks the highlight on the middle figure's hose and a few deft strokes on the coats give them a lively texture.

The two National Gallery paintings are almost certainly datable to the period after Canaletto's return to Venice. Stylistically they have the hallmark of these years: a rapid confident brushstroke and a highly accomplished use of a painterly shorthand for the figures; there is a masterly control over scenographic and perspectival effects and a thoughtful use of contrasts of light and shadow. They can perhaps be dated to the later 1750s.

Although Canaletto's later years are not well documented and his production of paintings seems to have slowed down considerably, he remained active as a draughtsman. In fact, among his most ambitious drawings are the set of twelve *Festivals of the Doge* (of which only ten are now known) made in about 1763 which measure more than half a metre across and show large crowd scenes against the backdrop of the piazza, the piazzetta and other Venetian sites. Canaletto certainly did not feel his powers were fading. His last dated drawing, a view of the interior of San Marco (Hamburger Kunsthalle), is inscribed in his own hand and proclaims: 'I, Zuane Antonio da Canal, have made the present drawing of the Musicians who sing in the Ducal church of San Marco in Venice at the age of 68 without spectacles, the year 1766.'[28] Canaletto lived on for another two years.

52 *Study of Three Figures*, about 1745. Pen and ink and wash on paper, 92 x 133 mm. London, The British Museum.

Technique and Style in Canaletto's Paintings

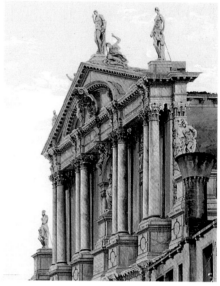

53 Detail of fig. 15 (*Venice: The Upper Reaches of the Grand Canal with S. Simeone Piccolo*).

IN USING THE CHANGING topographical details of Canaletto's paintings to explore eighteenth-century Venice it is easy to overlook the great changes in style that distinguish his earlier work from that of his maturity and later career. Even to those familiar with Canaletto it always comes as something of a shock to compare the brooding melodrama of his early pictures with the radiant, if formulaic, eternal springtime of his later work. Indeed, so different are the early works that some are only now being recognised as his.[29] Many painters develop in style from precise outlines and high-key colour in their early careers to looser forms and more restricted tonalities in their later works.[30] Canaletto travelled in the reverse direction. Probably reflecting his early training as a painter of stage scenery, his darkest, most theatrical, expressionistic phase came first; lighter colours and a routine precision bordering on slickness came later. In between – during the late 1720s and the 1730s – he produced a whole succession of masterpieces that combined an extraordinary breadth of vision with brilliant observation of detail and breathtaking skills in capturing light effects and material textures in paint.

The basic techniques that Canaletto employed can be summarised as follows.[31] He painted almost always on canvas: the only significant exception was a series of copper-plates – of which nine have survived – commissioned by Owen McSwiney in the late 1720s for various English collectors, including the Duke of Richmond. The canvases vary considerably in texture: that for *S. Simeone Piccolo* (fig. 15) is of an exceptionally fine weave, seemingly chosen to give a particularly smooth surface for one of the most brilliantly sustained and exquisitely detailed renderings of Canaletto's career (fig. 53). Those for *The Feast Day of Saint Roch* (fig. 35) and *The Stonemason's Yard* (fig. 42) are coarser and the paint handling correspondingly broader. Sizes varied a great deal also: the three paintings mentioned above are all grand in scale but many of the pictures are only a quarter of the size of these – a fact often overlooked when they are seen in reproduction. Although generally speaking smaller pictures might be expected to have finer canvases, this was not always the case: the two small Piazza San Marco paintings (figs. 48 and 49) have quite coarse textures that give the paint a pronounced chequerboard structure (fig. 54).

The canvases were invariably first prepared with grounds typical of Venetian painting at this period, ranging from red-brown through orange-brown to yellow-brown in colour. These might consist of single or double layers: *S. Simeone Piccolo* and *The Feast Day of Saint Roch* both have one layer of yellow-brown ground, *The Stonemason's Yard* has a yellow-brown layer over an orange-brown layer.[32] On this basic brick-coloured preparation, Canaletto would then apply broad expanses of underpaint which varied in colour and extent as his career progressed. In his earlier paintings, up to around 1727-8, he

underpainted sky, buildings and water separately and rather thinly so that the warm ground often shows through. The sky was laid in with grey, changing in tone from dark (sometimes very dark) on one side of the composition to light on the other, and the water with a uniform steely grey; buildings were underpainted with red or orange or were painted directly on the warm ground colour. After 1728 or so, Canaletto's preparatory technique simplified. He began to cover the entire picture area with a uniform layer of pale grey or (more usually) beige over the brick-coloured preparation: this was, essentially, an additional light-coloured ground layer and is sometimes described as such in the technical literature. *S. Simeone Piccolo* and *The Feast Day of Saint Roch* both have this layer; *The Stonemason's Yard* does not – indicating a date of not later than 1727–8.

The introduction of this pale underlayer accounts for the dramatic change between the hot, dark tones of the early paintings and the blond, cool light in the paintings that followed. It was clearly a conscious choice that imposed a specific look on the paintings – a paler look that Canaletto was already experimenting with on the copperplates. There had certainly been sunlight in the early works on canvas (after all, Alessandro Marchesini had advised Stefano Conti to buy paintings from Canaletto in 1725 because he was skilled 'in making the sun shine' in his pictures), but it was often a fitful, glittering sun, glimpsed between storm clouds – and not the steady silver light that the Grand Tourists wanted for their mementoes of the Serenissima under blue skies and in perpetual spring. The change in technique set a new tonality more in keeping with the requirements of the market.

Canaletto's painting materials were more or less conventional. He used the standard range of pigments available in eighteenth-century Venice, in a linseed or walnut oil medium.[33] The only notable feature of his palette was that he was one of the very first painters in Europe to use the synthetic pigment Prussian Blue which had been discovered only in 1704. It is interesting to note that Marchesini, in order to explain Canaletto's delay in beginning the pictures that Conti had ordered in July 1725, wrote to Conti in the September of that year of the difficulties the painter was having in obtaining his preferred blue pigment and its expense.[34] This has always been interpreted as procrastination and a demand for more money, but it is perfectly possible that Canaletto's problems in obtaining large quantities of Prussian Blue, at that stage a novel material, were real enough.

The most striking feature of Canaletto's technique is the development of his brushwork – the ways in which his handling of paint changed from the flickering touches of the first pictures to the extraordinary assurance, skill and ingenuity of his early maturity to the eventual mechanical repetition of much of the later work.

In the four paintings made for Stefano Conti, all the elements of Canaletto's early style are seen in their most developed form (figs. 9 and 11). The extremes of light and shadow; the dramatic sweep of sky from dark threatening clouds to watery sunshine; the smooth green, slightly menacing water, with few ripples or reflections; the small angular, animated figures – all are present. The brushwork still has the somewhat ragged, wispy

54 Detail of fig. 49 (*Venice: Piazza San Marco and The Colonnade of the Procuratie Nuove*).

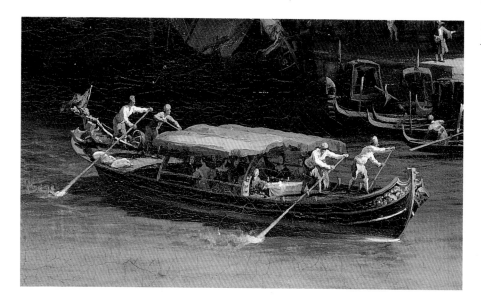

quality of the earliest paintings. The buildings are painted with variegated touches of colour and the architectural elements are outlined in black, with obvious use of a ruler for straight lines. From his earliest known pictures, Canaletto delighted in including sharp, vivid details caught by glancing shafts of sunlight. In the Conti painting of *The Grand Canal with the Rialto Bridge from the North* for example, the boatmen on the *peota* and the gondolas in the foreground are brilliantly conceived – little sinewy shapes straining against their oars, brightly highlighted against the shadowed water behind (fig. 55). In the same picture, the tiny figure of a workman slung under the eaves of the Fabbriche Vecchie just catches the light and, above him, Canaletto paints the low sun picking out the uneven roof tiles (fig. 56) in just the same manner as he was to do more than a decade later in *S. Simeone Piccolo* (fig. 18).

The View on the Grand Canal from the Ferens Art Gallery (fig. 26), which would appear to date from around the same time or slightly earlier, has many of the same characteristics but the whole structure is simplified. Light and shade are even more dramatically contrasted so that rather little detail can be made out in the shadowed façades on the right – the architecture here is reduced to simple outlining in black. Detailed rendering of the sunlit façades on the left is confined to the nearer buildings and the Rialto Bridge is defined only in outline. Roofs are solid blocks of colour with no indication of individual tiles. The sky is underpainted with dark grey through which the brown ground shows and a flight of white birds against the darkest passage at the left accentuates the threatening atmosphere. The water is a smooth grey-green with a faint indication of ripples and only intermittent reflections. The small wiry figures go about their solitary work, each briefly becalmed in the harsh glare of the morning sun before the storm sweeps in from the west.

56 Detail of the roof of the Fabbriche Vecchie in fig. 9 (*Grand Canal: the Rialto Bridge from the North*).

57 Detail of fig. 42 (*The Stonemason's Yard*).

58 Detail of fig. 35 (*Venice: The Feast Day of Saint Roch*).

In these paintings, the ragged strokes of Canaletto's earliest work are giving way to a descriptive brushwork that imitates forms and textures. Painted highlights on sails and clothing represent real folds of material and cast real shadows. *The Stonemason's Yard* (fig. 42) – probably painted a year or two later – represents a turning point in Canaletto's style, technique and psychological engagement with the Venetian scene. Warm tones and localised underpaint look back to the earlier technique. Shadows remain deep and the water is still dark green. There are echoes, too, of atmospheric drama but the storm clouds are dispersing. In his handling of paint, though, Canaletto has moved on and is on the brink of his mature style. Descriptive impasto is now beginning to stand for a variety of textures and materials – clothed figures, the line of washing on the far side of the canal, sunblinds on the house at the right, blocks of stone, the wood of the workman's hut – all are captured with brushstrokes that mimic the real forms they represent. But the potential of paint for depicting the crumbling or weathered walls of buildings has not yet been fully realised: these passages are still constructed in terms of relatively flat, variegated colour with black or grey outlining. The use of simple geometrical instruments is evident: wall and roof lines and windows are ruled using a straight-edge and regular curves are constructed with compasses. The blind arcade running along just below the roof of the Carità has the hole of a compass point at every corbel (fig. 57).

During the 1730s works of astonishing quality and complexity were produced and *The Feast Day of Saint Roch* of around 1735 and *S. Simeone Piccolo* of 1738 are two of the most remarkable. *The Feast Day of Saint Roch* is painted on the usual (by this time) beige preparation and then laid in with grey underpaint, slightly warmer under the buildings and foreground. The grey shows through in many places; it is seen completely unmodified in the hand of the Cancelliere Grande, the principal figure in scarlet immediately preceding the Doge (fig. 59). Overall, the influence of this underlying grey gives the picture a misty tonality. The slightly hazy effect is accentuated by the use of soft washes of low-key colour for much of the architectural detailing on the Scuola itself. At the top, the wall below the cornice appears to take on the colour of the sky, adding to its air of insubstantiality. Ruled lines and use of compasses are apparent everywhere: the expected compass puncture is still visible at the centre of each roundel and arch (fig. 58). The sequence of painting can be seen by examining the picture surface. The architecture was painted first over its warm grey underpaint and completed even down to the steps leading up to the door of the Scuola: although the steps cannot be seen, there are clear horizontal lines beneath the figures which now obscure them. The figures, the awning, the displayed paintings and the garlands were all painted over the completed architecture with bravura use of impasto and spirited brushwork. The sky in this picture – although not in others – seems to have been painted around the buildings: prominent brushstrokes follow the roof-lines. The clouds are now the quite unthreatening frothy white and cream confections that Canaletto was habitually painting by this time.

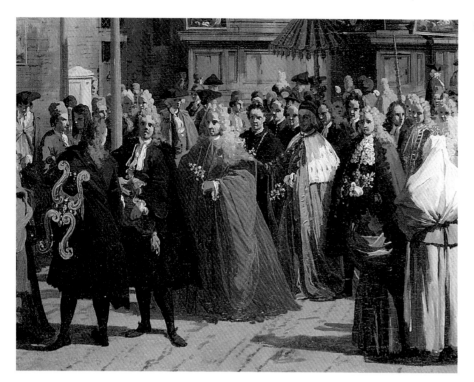

Canaletto's depiction of architecture had changed significantly in the early 1730s. As Viola Pemberton-Pigott has written, 'he extended his ability to model his figures in the wet paint into his painting of buildings'.[35] Architectural renderings began to be modelled in low relief by manipulating paint levels and textures. Grooves and ridges with actual shadows stood for columns, lintels, balustrades and steps. Incising the wet paint along straight-edges or around curves indicated mouldings or surface patterning on walls. Broken, dabbed brushwork imitated decaying stucco and weathered brick. The sharp black outlining used until then softened into subtly controlled lines or washes of grey or brown and the buildings seemed to take on an almost tangible depth and substance.

S. Simeone Piccolo, one of Canaletto's most lucid and radiant paintings, represents the artist at the height of his powers (fig. 15), with its brilliant use of texture overlaid with precise delineation of form in a combination of painted outlines, translucent washes and incised lines. The sunlit façades and roofs on the left sparkle with varied brushwork and crisp detail, while the shadowed buildings on the right are constructed in softer tones and flatter paint – all so skilfully done that the whole feel of a slightly crumbling Venice comes alive (fig. 60). Even more remarkable is the painting of the distant houses on the bend of the Canal caught in the oblique afternoon sunshine: here, every wall, window, door and moulding is observed with total clarity while losing nothing of the variation of texture that gives them their three-dimensional reality. The order of

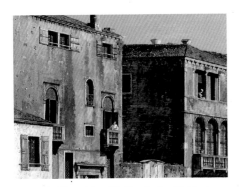

60 Detail of fig. 15 (*Venice: The Upper Reaches of the Grand Canal with S. Simeone Piccolo*).

working in this painting is Canaletto's usual one. The sky was painted first and horizontal brushstrokes can be seen to go under the roof-lines for a little way; the buildings and water were completed before the boats and figures were painted on top.

The water in *S. Simeone Piccolo* shows considerable variation: the ripples change shape and increase or decrease in different parts of the canal and reflections are precise and realistic. In the National Gallery regatta scene of two or three years later (fig. 28) the water is represented by repetitive loops and curls and there are no reflections. Although this picture and its pendant, *Venice: The Basin of San Marco on Ascension Day*, are impressively large, showy and immaculately detailed pieces of bravura painting, they are noticeably more mechanical in execution. Colours are vivid but generally flatter and hard black outlining is used everywhere. The creamy white clouds are freely and thickly painted, but the use of imitative texture in the cityscape is now confined to one or two side walls of palaces catching the light, the multicoloured plumes and decorations for the regatta and the multitude of little figures. The distant buildings leading to the Rialto Bridge are painted in grey, giving an appearance of misty distance and aerial perspective (fig. 61). As usual, the painting of the sky preceded the buildings, water and boats and the figures were added last.

The two little late piazza scenes (figs. 48 and 49), painted after Canaletto's return from England, show his confident, rapid technique of those years. All colours are now flat except for a little impasto on the figures; topographical and architectural detailing

61 Detail of fig. 28 (*A Regatta on the Grand Canal*).

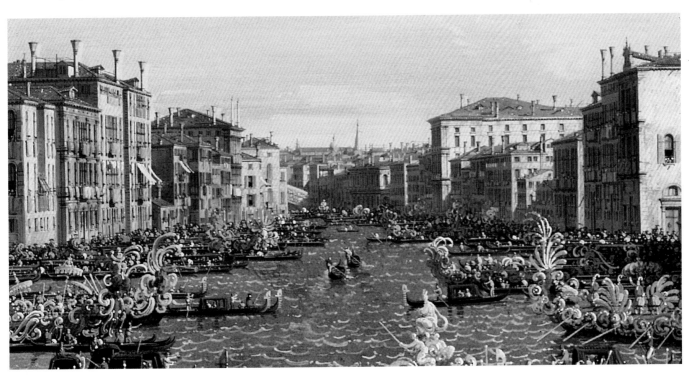

consists of regular black outlines. A steady silver light pervades the scene. Over the course of his career, he has arrived at an assured, seemingly effortless formula for depicting his city and its citizens.

It is – perhaps unexpectedly – in his portrayal of the human figure that we can best identify the evolution of Canaletto's style and temperament. Even allowing for differences in scale, it is possible to trace the way in which he engaged with his subjects by examining a succession of figures from all phases of his career. Even the smallest figures in the earliest works are individual and varied. In the Conti paintings they are small, animated and spiky (fig. 55); *The Stonemason's Yard* is full of incident, the foreground figures highly individualised (fig. 62); in the *Feast Day of Saint Roch* an all-purpose facial structure has clearly developed but the characterisation and narrative sense are vivid (fig. 59); in *S. Simeone Piccolo* individuals are still sharply observed – the fat helmsman on the *burchiello* at the left is one of Canaletto's most successful evocations of real character (fig. 63). Always, of course, there was a difference between the principals in action in the foreground and the supporting roles in the background – and the smaller figures in the distance of *S. Simeone Piccolo* are certainly relatively static. But, even so, the main players in the National Gallery *Regatta* of about 1740 (similar in scale to the background figures in *S. Simeone Piccolo*) are notably more doll-like (fig. 64). They correspond to the formula that Canaletto was to employ for the rest of his career for conjuring up large numbers of figures at great speed. Faces consisted of an extended highlight for the forehead and cheek, two dots for chin and nose – all done in a second or two with paint perfectly formulated to hold its shape; clothes were dashed in with a few sweeps of the brush. Some of the English paintings were even more pictographic: the figures in *Eton College* are

62 Detail of fig. 42 (*The Stonemason's Yard*).

63 Detail of fig. 15 (*Venice: The Upper Reaches of the Grand Canal with S. Simeone Piccolo*).

64 Detail of fig. 28 (*A Regatta on the Grand Canal*).

abbreviated even by Canaletto's standards (fig. 65). In the late Venetian paintings, the figures have regained some of their former interest but the calligraphic formula of pastose dots for forehead, cheek, nose and chin remains (fig. 66). Canaletto never returned to the animation, the narrative sense or the affectionate characterisation of his earlier career.

In tracing Canaletto's developing method of setting down the Venetian scene in paint on canvas, it is inevitable that changing styles will be equated with a rise to brilliance and subsequent decline. Most writers – as here – draw attention to Canaletto's adoption of a more 'mechanical' way of working in his later career: but it is important to remember that such descriptions are relative to the extraordinary achievements of his greatest work and that, even when he fell back on hard-won experience to satisfy the demands of collectors for affordable souvenirs of an ideal Venice, the paintings he produced were still beyond the capabilities of other contemporary view painters.

Painters use technique in the service of illusion. The illusions that Canaletto created of his native city are so complete that we cannot resist testing them against reality. Canaletto made his paintings from the same materials available to other painters, but his assurance, precision and skill in handling them were without equal. Technical genius and a profound sense of the beautiful conspired to create images that make us marvel still.

65 Detail of *Eton College*, oil on canvas, 1754. London, The National Gallery.

66 Detail of fig. 49 (*Venice: Piazza San Marco and the Colonnade of the Procuratie Nuove*).

Bibliography

Baetjer, K., and Links, J.G., *Canaletto* (exhibition catalogue), Metropolitan Museum of Art, New York, 1989.

Bomford, D., and Roy, A., 'Canaletto's *Venice: The Feast Day of Saint Roch*', *National Gallery Technical Bulletin*, 6 (1982), pp.40–4.

Bomford, D., and Roy, A. 'Canaletto's "Stonemason's Yard" and "San Simeone Piccolo"', *National Gallery Technical Bulletin*, 14 (1993), pp.34–41.

Constable, W.G., *Canaletto* (2 vols), Oxford, 1962; 2nd edition revised by J.G. Links, Oxford, 1976; 3rd edition with supplement by J.G. Links, 1989.

Corboz, A., *Canaletto: Una Venezia Immaginaria* (2 vols), Milan, 1985.

Franzoi, U., and di Stefano, D., *Le Chiese di Venezia*, Venice, 1976.

Gioseffi, D., *Canaletto. Il Quaderno delle Gallerie Veneziane e l'impiego della camera ottica*, Trieste, 1959.

Hammond, J., *The Camera Obscura*, Bristol, 1981.

Haskell, F., 'Stefano Conti, Patron of Canaletto and Others', *Burlington Magazine*, 98 (September 1956), pp.296–300.

Helston, M., *Second Sight: Canaletto and Guardi*, London, 1982.

Lauritzen, P., and Zielcke, A., *Palaces of Venice*, Oxford, 1978.

Levey, M., *The Seventeenth and Eighteenth Century Italian Schools*, National Gallery, London, 1971.

Links, J.G., (introduction and commentary) *Views of Venice by Canaletto, Engraved by Visentini*, New York, 1971.

Links, J.G., *Canaletto and his Patrons*, London, 1977.

Links, J.G., *Canaletto*, Oxford, 1982; 2nd edition, London, 1994.

Links, J.G., *Venice for Pleasure*, 6th revised edition, London, 1998.

Lorenzetti, G., *Venice and its Lagoon*, English translation by J.Guthrie, Trieste, 1975.

Miller, C., and Millar, O., *Canaletto* (exhibition catalogue), The Queen's Gallery, Buckingham Palace, London, 1980.

Nepi Scirè, G., *Canaletto's Sketchbook*, facsimile edition of the sketchbook in the Venice Accademia with a volume of commentary, Venice, 1997 (English edition).

Parker, K.T., *The Drawings of Antonio Canaletto in the Collection of His Majesty the King at Windsor Castle*, Oxford and London, 1948.

Pemberton-Pigott, V., 'The Development of Canaletto's Painting Technique' in Baetjer and Links 1989 (see above).

Pignatti, T., *Il Quaderno di disegni del Canaletto alle Gallerie di Venezia*, 2 vols, Venice, 1958.

Renier Michiel, G., *Origine delle Feste Veneziane* (6 vols), Milan, 1829.

Notes

1 See the perceptive comments of Michael Levey in his essay 'Canaletto as artist of the urban scene' in Baetjer and Links 1989, pp.17-29.

2 A thorough analysis of the modifications that Canaletto makes to individual buildings and to the actual topography of his city views is provided in Corboz 1985, II, chapter 3.

3 See Miller and Millar 1980, Parker 1948 and the essay by Alessandro Bettagno entitled 'Fantasy and Reality in Canaletto's Drawings' in Baetjer and Links 1989, pp.41–52.

4 A recent facsimile edition with a brief commentary in English is that published by Nepi Scirè 1997.

5 See Haskell 1956.

6 The letter is reproduced in Baetjer and Links 1989, Appendix, p.361. The translation given above differs slightly from the one given there.

7 See for example, Baetjer and Links 1989, cat. 91, p.290.

8 On this subject see Pignatti 1958 and Gioseffi 1959; see also Hammond 1981, Corboz 1985 and most recently M. Kemp, *The Science of Art*, New Haven and London, 1990, pp.196–7.

9 Anton Maria Zanetti (the younger), *Della pittura veneziana e delle Opere Pubbliche de'veneziani maestri*, Venice, 1771, pp.462–3. Quoted in Links 1977, p.59.

10 The painting is catalogued in Baetjer and Links 1989, cat. 23.

11 Renier Michiel, quoted in I. Reale and D. Succi, *Luca Carlevarijs e la veduta veneziana del Settecento* (exhibition catalogue), Padua, 1994, p.211.

12 For a detailed and accurate account of the history of the regatta, see E.A. Cicogna, *Lettera [...] intorno ad alcune Regate Veneziane*, Venice, 1856.

13 See for example, those reproduced in J. Martineau and A. Robison, *The Glory of Venice*, (exhibition catalogue), London, The Royal Academy, 1995, cats. 207 and 266.

14 Renier Michiel 1829, VI, p.187.

15 The fullest description of the ceremony is given in Renier Michiel 1829, IV, pp. 60-8.

16 Compare the portrait of him by Bartolomeo Nazari in the Accademia dei Concordi, Rovigo, reproduced in the exhibition catalogue, *Fra Galgario e il Settecento* (exhibition catalogue), Bergamo, 1955, cat.56.

17 For the history of San Rocco, see G. Nicoletti, *Illustrazione della Chiesa e Scuola di S. Rocco*, Venice, 1885, and most recently, Franzoi and di Stefano 1976, pp.48–50.

18 Canaletto painted the sun shining impossibly from the north in other paintings also: a well-known example is *SS. Giovanni e Paolo and the Monument to Bartolomeo Colleoni*, Royal Collection, engraved as plate 1 of the third part of the 1742 edition of Visentini's *Prospectus*.

19 On the subject of exhibitions in eighteenth-century Venice, see F. Haskell and M. Levey, 'Art exhibitions in 18th-century Venice', *Arte Veneta*, XII, 1958, pp.179–85.

20 See Haskell 1956, p.298.

21 'A View in Venice, with the Doge going in Procession, on St. Luke's Day; capital, from the Vatican.' Christie's, London, 2 March 1804, lot 37.

22 The date (27 May 1744) is reliably given in Franzoi and di Stefano 1976, p. 220; other dates are quoted in other accounts.

23 Levey 1971, p.21.

24 Quoted in Baetjer and Links 1989, p.336.

25 The drawing is at Windsor, see Parker 1949, no.55.

26 The watermark, of the 'Strasbourg Lily' type, is of Dutch origin and has only been found on Canaletto's English drawings.

27 One is in the Robert Lehman Collection, Metropolitan Museum of Art, New York, and the other was formerly in the Heinemann collection and recently sold at Christie's, New York, 1 July 1997, lot 78.

28 See Baetjer and Links 1989, cat.127.

29 See, for example, Links 1994, plate 17, formerly attributed to Marieschi.

30 This theme is developed in Kenneth Clark's essay 'The Artist Grows Old' in *Moments of Vision*, London, 1981.

31 See Pemberton-Pigott 1989 and P. England, 'An Account of Canaletto's Painting Technique' in Miller and Millar 1980, pp.27-8.

32 See Bomford and Roy 1982 and Bomford and Roy 1993.

33 Bomford and Roy 1993.

34 See Haskell 1956.

35 Pemberton-Pigott 1989, p.57.

Works in the Exhibition

Ludovico Ughi, *Map of Venice*. 152 x 215 cm.
London, British Library (fig. 2).

Venice: The Feast Day of Saint Roch.
Oil on canvas, 147.7 x 199.4 cm.
London, National Gallery (fig. 35).

Luca Carlevaris, *Scuola di S. Rocco.*
Etching, 203 x 289 mm (platemark).
London, British Museum (fig. 34).

*Venice: The Upper Reaches of the Grand Canal with
S. Simeone Piccolo.*
Oil on canvas, 124.5 x 204.6 cm.
London, National Gallery (fig. 15).

Follower of Canaletto, *Venice: S. Simeone Piccolo.*
Oil on canvas, 38.8 x 47 cm.
London, National Gallery

Follower of Canaletto, *Venice: Upper Reaches of the
Grand Canal facing Santa Croce.*
Oil on canvas, 38.8 x 46.3 cm.
London, National Gallery.

Venice: S. Simeone Piccolo.
Pen and ink on paper, 227 x 375 mm.
Windsor, Royal Library (fig. 20).

Follower of Canaletto, *Venice: Upper Reaches of the
Grand Canal facing Santa Croce.*
Oil on canvas, 59.7 x 92.1 cm.
London, National Gallery (fig. 23).

Grand Canal: the Rialto Bridge from the North.
Pen and brown ink with red and black chalk on
paper, 140 x 202 mm.
Oxford, Ashmolean Museum (fig. 10).
London only

Grand Canal: looking North from near the Rialto Bridge.
Oil on canvas, 91.3 x 135 cm.
Private Collection (fig. 11).
London only

Grand Canal: the Rialto Bridge from the North.
Oil on canvas, 91.5 x 135.5 cm.
Private Collection (fig. 9).
London only

Venice: A Regatta on the Grand Canal.
Oil on canvas, 117.2 x 186.7 cm.
London, National Gallery (fig. 27).

A Regatta on the Grand Canal.
Oil on canvas, 122.1 x 182.8 cm.
London, National Gallery (fig. 28).

*Grand Canal: looking North-east from the Palazzo Balbi
to the Rialto Bridge.*
Oil on canvas, 66.6 x 97.7 cm.
Hull City Museums and Art Galleries, Ferens
Art Gallery (fig. 26).

Luca Carlevaris, *Studies of Gondolas and Figures.*
Oil on canvas, 19 x 31.8 cm.
Birmingham, Museum and Art Gallery (fig. 30).

*Venice: Campo S. Vidal and Santa Maria della Carità
('The Stonemason's Yard').*
Oil on canvas, 123.8 x 162.9 cm.
London, National Gallery (fig. 42).

*Venice: The Grand Canal from the Carità
towards the Bacino.*
Oil on canvas, 47.9 x 80 cm.
Windsor, Royal Collection (fig. 43).

*Venice: The Lower Reaches of the Grand Canal facing the
Volta del Canal.*
Pen and ink on paper, 220 x 376 mm.
Windsor, Royal Library (fig. 44).

Venice: Piazza San Marco.
Oil on canvas, 46.4 x 37.8 cm.
London, National Gallery (fig. 48).

*Venice: Piazza San Marco and the Colonnade of the
Procuratie Nuove.* Oil on canvas, 46.4 x 38.1 cm.
London, National Gallery (fig. 49).

Venice: The Campanile of S. Marco damaged by Lightning.
Pen and brown ink and wash on paper,
451 x 288 mm.
London, British Museum (fig. 50).

Study of Three Figures. Pen and ink and wash on
paper, 92 x 133 mm.
London, British Museum (fig. 52).

*Venice: S. Marco seen from the Arcade of the Procuratie
Nuove.* Pen and ink and bluish-grey wash on
paper, 193 x 284 mm.
Windsor, Royal Library (fig. 51).